Marc McQuade Architecture [...] are often thought of as proce[...] of constraints. In your studio [...] standard parameters like pr[...] dom to imagine and project instead. This was clearly a non standard and uncomfortable way of working for the students, but a quite normal approach for many artists — and therefore a great tie-in with Teresita Fernández. Could you talk a bit about your strategy here? Is this how you approach your own work, ideally? Is this something that you experienced in your own education? I'm particularly curious about this approach given your work with the National Museum of African American History and Culture, a project that must have a complex number of constraints and regulations to negotiate and consider.

David Adjaye The discipline of architecture is, at its essence, a way to think about civil society and translate the building requirements beyond the basic needs of the clients. Architectural education often fails to teach this and instead focuses on defining the programme at the outset and developing a design according to the programme constraints. What we have to remember (and what architectural education too often forgets) is that architecture is more than simply providing answers to a set of questions; architecture is about deducing what the questions really are.

Before pursuing my architecture degree, I did a foundation degree in art. This provided me with a very broad foundation in art practice. After completing my architecture degree, I chose to attend an art school where I could interact with artists and makers who were asking more fundamental questions—questions addressing morality and social context in design, and how the maker can and should respond to these questions.

Traditional architecture schooling often stresses the use of technology to develop new forms, instead of investigating the meaning of form in the time in which we live. This is a

very defeatist approach, as it neglects the core purpose of architectural practice: Defining the question. There is a duality that exists—the balance between the philosophical ideas and the practical answers that architecture can offer. I propose that thinking, and the process of idea generation, is far more important than perfecting a technique.

The challenge with a project like the National Museum for African American History and Culture, or any other project for that matter, is developing a philosophical idea for the project that is so robust and meaningful that it translates beyond the programme. The museum, for example, will not be significant for the rooms and artifacts it contains. Rather, its significance will be realized in the experience as interpreted by the user, and this experience stems from a core idea that perpetuates the entire design concept. When the client realizes that the philosophy of the design parti is the core of the project and, ultimately, dictates the programme, negotiating through the regulatory agencies becomes much simpler because everyone is "buying into" the idea, not the programme. This is the challenge of architecture: To design according to the questions, not the answers.

Marc McQuade In the beginning of the studio you countered the typical approach to "site analysis"—which is often an exercise in information graphics, redrawing site maps, and filtering through data—by asking the students to spend two weeks observing and documenting their personal experiences of the site. From color and varying degrees of light levels to reflections and sounds, every student focused on the radically different site conditions that impacted them. Could you talk a bit about this approach? How do these very personal experiences play a role in architecture's ability to affect a larger community and, ultimately, the city? How does the personal experience become a "collective memory"?

David Adjaye In thinking of the concept of "collective memory," consider a city: You start with an individual memory and experience. As more people (and different cultures of people, at that) immigrate into and populate the city, the individual memory expands to encompass multiple memories and experiences and ideas. The collective memory develops in that architecture is read the same way because of the urban context in which it exists, regardless of the different kinds of people who settle there.

As urbanization in cities grows and becomes more complicated, this idea of the "collective memory" of place must be continually revisited, evaluated, and criticized. The varied experiences of differing populations will naturally lead to a different idea and experience of place, and for architecture to exist in its true form, it must be read according to how it was designed. Hence, the collective memory tells an accurate story of the architecture—how it came to be, and how it should be interpreted.

The studio exercise of allowing each student to experience space in their own manner enabled them to develop an "individual memory"—for once they understood the individual experience, they were then able to understand why the collective memory is so important in defining place and space and time and culture. Collective memory forces the design to have purpose and meaning that is clear and intentional. When the community believes in the collective memory, then the architecture lives as it was intended.

David Adjaye

Authoring

re-placing art and architecture

Teresita Fernández

Jorge Pardo

Matthew Ritchie

Edited by Marc McQuade

Princeton School of Architecture

Lars Müller Publishers

Re-authoring communities
Jorge Pardo

New Jersey/Gowanus/Yucatán

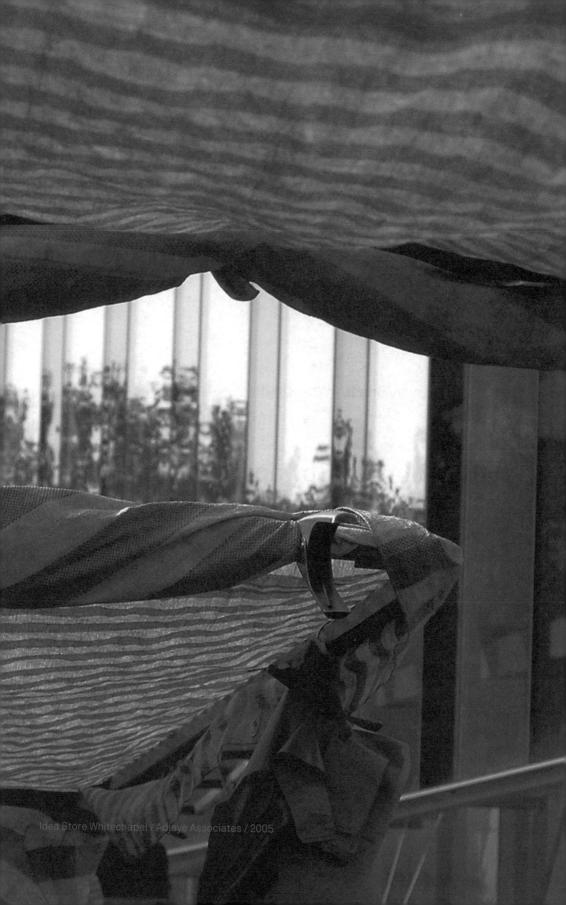

David Adjaye's Expanded Field

Stan Allen

It seems to me that architecture is radiated by a building and does not clothe it, that it is an aroma rather than a drapery: an integral part of it and not a shell.
–Le Corbusier, "Concerning Architecture and Its Significance" 1926

Rosalind Krauss' seminal 1979 essay "Sculpture in the Expanded Field" begins with the description of an earthwork by Mary Miss:

> Toward the center of the field there is a slight mound, a swelling in the earth, which is the only warning given for the presence of the work. Closer to it, the large square face of the pit can be seen, as can the ends of the ladder that is needed to descend into the excavation. The work itself is thus entirely below grade: half atrium, half tunnel, the boundary between outside and in, a delicate structure of wooden posts and beams.[1]

It is worth pointing out that the terms used, as well as the language of the artwork itself, are exclusively architectural. In the wake of minimalism, artists of the 1970s had turned to landscape, architecture, video, photography, and performance. Surveying this diverse production, Krauss writes that "rather surprising things have come to be called sculpture: narrow corridors with TV monitors at the ends; large photographs documenting country hikes; mirrors placed at strange angles in ordinary rooms; temporary lines cut into the floor of the desert." She goes on to point out that the effect of such a production has been to make the category of sculpture seem "almost infinitely malleable." "Categories like sculpture and painting," she writes, "have been kneaded and stretched and twisted in an extraordinary demonstration of elasticity." For Krauss, this elasticity of categories has had the opposite effect intended: "We had thought to use a universal category to authenticate a group of particulars, but the category has now been forced to cover such heterogeneity that it is, itself, in danger of collapsing."

In a passage that must have seemed unexpected at the time, she reasserts the idea of sculpture as a fixed category, with its own internal logic and history: "I submit that we know very well what sculpture is. And one of the things we know is that it is a historically bounded category and not a universal one." Sculpture, for Krauss, is structurally tied to place, commem-

oration, and legibility. It follows more or less established rules and operates according to a consistent internal logic that finds its formal expression in verticality and figuration: "The logic of sculpture, it would seem, is inseparable from the logic of the monument." The metaphor of the field therefore connotes both the formal dissolution of monumentality into a dispersed, field-like array as well as the promiscuity of disciplinary categories. For Krauss, this loose interdisciplinary borrowing can only gain traction by working against the inherent logic of the discipline itself. Her essay unfolds around this tension between the late modern, or postmodern, fluidity of sculpture's field and the certainty of sculpture's internal disciplinary logic.

I believe it is nearly impossible to make any such categorical statement about architecture's identity as a discipline, either on the basis of historical example or current practice. Architecture has always operated in an expanded field. Water clocks, fortifications, and astrology were part of architecture for Vitruvius, and today architects are working in landscape, urbanism, product design, installation, and infrastructure. Modernism in architecture involved exchange with other practices, including painting, sculpture, and engineering. Architecture was a nomadic field from the outset, borrowing from other practices and operating in a wide range of related fields. Perhaps nobody understands this better than David Adjaye. It is commonplace to say that Adjaye's practice is bound up with the art world; his first clients were artists and his current clients are collectors and museums. He has collaborated with artists who are his close friends, and he operates cannily within the art world, which has been for him not only a source of work but a source of creative sustenance. But what lessons has he learned from the art world? How has he navigated the geography of architecture's expanded field?

Adjaye is well aware of the complex interplay between art and architecture over the course of the twentieth century. He belongs to an established genealogy of architects working at the intersection of art and architecture, but he mobilizes the

art/architecture axis differently than his predecessors did. Adjaye came to architecture relatively late, by way of an art school education, immersed in the heterogeneity of contemporary art production.[2] He is fully aware that the art world he inhabits has expanded to include not only architecture, but theater, film, performance, and everyday life itself. Despite Rosalind Krauss' best efforts, the genie is out of the bottle, and art and architecture both operate freely in an "expanded field," without regard for conventional disciplinary categories. Today it is harder and harder to say what does and does not qualify as art.

For Adjaye, as for many of his artist peers, this is less a problem than an opportunity. His collaborations are based not so much on the friction, or tension, between different disciplines as they are on an awareness that both sides of the collaboration are working on similar issues from different perspectives. "I like to collaborate with artists that see space and structure as integral to their work. It involves a merging of skills and aesthetics to create something that has more potential than either discipline can achieve on its own."[3] In fact many of the artists he collaborates with work in conditions that approximate an architecture office—a collective of assistants and collaborators who bring different expertise to bear on a series of commissioned projects—rather than the conventional idea of the solitary artist working in the studio. In these collaborations it is not so much a question of formal interplay as locating a shared territory and creating a working dialogue. This was evident in the collaborative studios taught at Princeton as well. Rather than impose his architectural ideas on his artist collaborators, Adjaye most often acted as a "translator," finding a language or a means to make the ideas of the artists intelligible and consequential in an architectural context.

On a number of occasions, Adjaye has worked with the painter Chris Ofili, both as a collaborator on architectural projects and to design installations of Ofili's work. In the installation designs, Adjaye defers to the artwork in the sense that the paintings

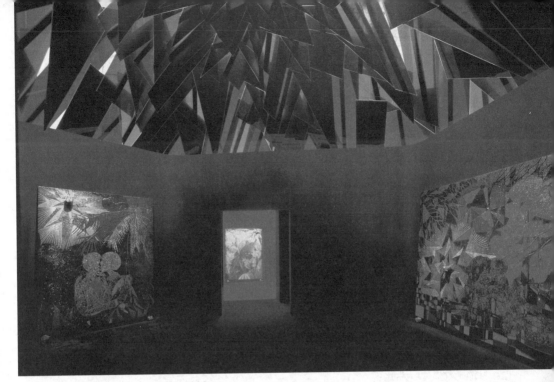

Within Reach / Adjaye Associates / 2003

are the primary focus of the space. Indeed, what Adjaye's installations do is amplify the presence of the paintings not by neutralizing the architecture but by intensifying it. In the 2002 "Upper Room," he accomplishes this by prolonging the passage leading to the viewing space, and creating a space within a space. At the British Pavilion of the 2003 Venice Biennale, the super-saturated color of the walls creates a space of heightened perceptual awareness that serves to focus attention on the works displayed within. The architecture does not upstage the painting but, without any aggression whatsoever, it radically alters our perception of the work, trading the clinical white cube for a theatrically lit box of colors. Ofili's work has a somewhat different presence in the Nobel Peace Center, where it works as one of many surface strategies to transform the interiors of the historic building. (Adjaye has described the building as "almost entirely about atmosphere.")[4] Color and surface here have a narrative function, as in the foyer where the intense red recalls the history of conflict that is the inevitable counterpart to the work of peacemaking. In this case, attention is not so much

focused as shattered and multiplied by the many reflective surfaces and episodes of saturated color.

This play of perception and experience also characterizes Adjaye's 2007 collaboration with Olafur Eliason in the T-B A21 Pavilion. Here Adjaye again works with a prolonged entry sequence, which in this case serves the practical function of allowing the visitor's eyes to adjust to the darkened room. The rhythmic pattern of slats provides a physical analog to the physiological sensations that are the basis of the artwork. At a time when so much art installation works with projection, often in jury-rigged darkened galleries, this reassertion of physical presence is a welcome change. Paradoxically, by reasserting the material presence of the container, the properties of the materials sometimes seem to trade places: the effect is as much to physicalize the light as it is to dematerialize the architecture.

The client is also a collaborator, and Adjaye's earliest projects involved houses, often for artist friends. These houses are usually straightforward in their spatial organization, and reflect a familiarity with the day-to-day realities of contemporary urban life. Responding to tight urban lots, the complexity of these houses is more often in section than in plan. They don't reproduce conventional domestic patterns; rather they follow a straightforward logic of function. (Artists, contrary to popular belief, are often very pragmatic in their choice of living and working space: That is the beauty of the loft.) These are houses made for living and working, and not for display. They follow the dictum of Adolf Loos that "[t]he house should be withdrawn on the outside, revealing all its riches inside."[5] They assert their presence primarily through unexpected material choices: The black anti-graffiti paint over the brick walls of the Dirty House, the blank plywood panels at the Elektra House, or the corten steel panels at the LN House. Suggesting a kind of material choreography, Adjaye has written that "each material plays its correct part within the scenography of the whole."[6]

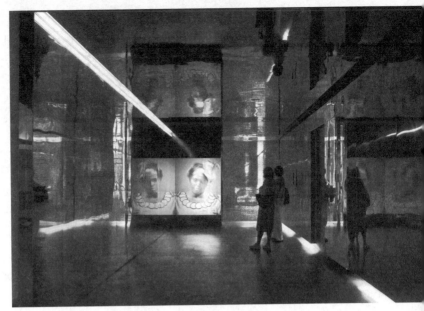

Nobel Peace Center / Adjaye Associates / 2005

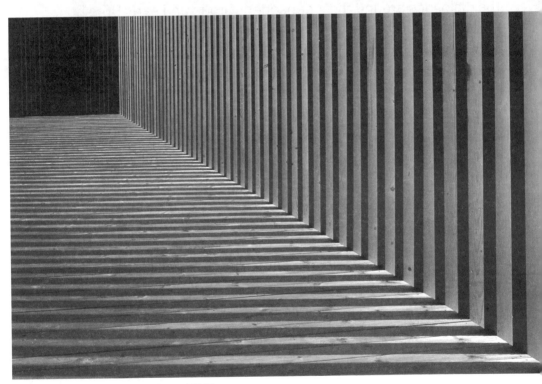

T-B A21 Pavilion / Adjaye Associates / 2007

In Adjaye's work, there is an improvisational, material intelligence that is surely another lesson taken from art world practice. There are exceptions of course, but artists, more often than architects, are able to maintain a direct contact with the materials of the work. Adjaye's buildings partake of this material and experiential reality. The materials in his projects take on an autonomous meaning apart from their specific role in the architecture. They serve to reinforce the reality of his works, as artifacts in the world. This direct and immediate expression of materials underscores the fact that his buildings are palpable, physical entities and not abstract statements; things found and not invented. It is not accidental that all publications of his work catalogue the materials used in scrupulous detail, and that a recent exhibition was organized around a kind of periodic table of materials.[7] His use of materials recalls another moment of productive overlap between art and architecture: the dialogues around the Independent Group and early British Pop Art, which it should be remembered unfolded against the backdrop of postwar austerity in Britain. Pop art in this context more often meant the gritty reality of urban life and the "as found" as opposed to the glossy surfaces later associated with American Pop Art. Looking back, Peter and Alison Smithson wrote that "the 'as found' was a new way of seeing the ordinary, an openness to how prosaic 'things' could re-energize our inventive activity."

Adjaye shares this trust in the power of ordinary objects and ordinary materials to reinvigorate the perception of the contemporary city: "In thinking about context I am always interested in social history, not in the academic sense but as it is lived—the immediacy of it."[8] His projects take their cues from the existing context, seeking a kind of modified fit, neither receding into the background nor aggressively asserting their presence. Instead they cultivate a series of small differences that cumulatively serve to produce consequential social effects. His is an architecture of familiar elements in unfamiliar relationships, rather than of new forms invented from scratch.

Chisenhale Road / Nigel Henderson / 1951

In the urban houses, the public dimension resides in their inter-section with the street and urban fabric; the interiors remain mostly private. It is in the larger public projects where the consequences of these material choices become evident as a social strategy. This is most visible in the Whitechapel Idea Store. Like the earlier but more modest Chrisp Street Idea store, the program is a community library and educational facility, intended to be completely open to the public. The Whitechapel building occupies a busy block in a highly diverse neighborhood: All of London's rich multicultural mix is on display here. In the Idea Store, the strategy of "as found" is extended to the interior of the building; in fact, both materially and organizationally, there is little distinction between exterior and interior public space. The public is drawn into the building and encouraged to move freely from space to space. By working consciously and unapologetically with cheap, familiar materials, Adjaye gives the architecture a slightly provisional feel that undercuts any pretension of formality. The architecture is demystified; slightly ad hoc, it is accessible, both literally and metaphorically, to anyone at all.

In the interiors, the exposed timber structure is alternately infilled with colored glass panels or blond wood. Nothing is covered up; anyone can see how it is made. On the exterior, the exuberant polychrome echoes the vitality of the local street culture. Adjaye has written: "I firmly believe that the richness of the city comes from its exteriority, rather than its interiority. My aim is to magnify this exteriority as an interior phenomenon, banning the conventional notion of the interior and replacing it with an interiority based on continuing the spatial pattern of the city, but at a different scale."[9] In this project, the "exterior-ity" of the city, that is to say, all the dynamism of street culture and the diversity of the neighborhood, is folded into the building interior to create a new hybrid public space. Commenting on the Whitechapel Idea Store, Okwui Enwezor observes that the archive—the space of cultural memory, so often buried deep in the library—is projected out into the public realm,

Idea Store Whitechapel / Adjaye Associates / 2005

"conjoined with the street."[10] The protected realm of cultural memory is no longer separated from the life of the city. In this way, the architecture of the Idea Store carves out a space for the inhabitants of the city to rewrite the archive, and thereby to create new cultural narratives.

In describing one of his early houses, Adjaye refers to the "informal," which he associates with the dynamic, changing character of the contemporary city: "The design was a critique of the Victorian Street and its insistence on a certain kind of formality, which was intended to support public life—whilst the back facades were completely informal... I believed that the previous formality was no longer an accurate reflection of the society we live in, and that the schizophrenia that it represented had to be reversed."[11] Although referring to a specific project, this is an observation that can be generalized in Adjaye's work. Architecture's institutional structure, its slow process of realization and the many hands involved, conspire against the improvisational,

the unfinished, or the open ended. Yet the life of a building only begins when the construction is complete. While notions of classical beauty may no longer seem relevant, architecture today still has a tendency toward formal resolution, and a sense of finality.[12] This issue has been unpacked to a much larger degree and with a much longer history in the art world. In painting and sculpture, the lack of finish—from *Art Brut* to a contemporary artist such as Thomas Hirschhorn— has acquired an ideological charge. These artists deploy the casual, and a kind of "deskilling" logic. Critical of the idea of the work as a distanced, formally autonomous object, finished and complete in itself, many artworks today depend on the viewer to complete the work of art, engaging in an active dialogue with an audience of viewer/participants.

Interestingly, it is possible to argue that this open-ended, experiential approach belongs less to art than to architecture, or more properly to the city. It is not surprising, for example, that many of these artworks operate at an architectural scale; they want to leave the institutional framing of the gallery or the museum behind. Like these artworks, a building like the Whitechapel Idea Store does not solicit distanced contemplation or nuanced reflection; indeed, it yields little to extended formal analysis. Instead, it looks to activate and engage its users. There is something stealthy about the way it works. First, it is deceptively open: it pulls the user in, quite literally, through the escalator and portico cantilevered over the sidewalk. Once inside, it gently forces engagement through the choreography of spaces, the use of light, and above all the palette of familiar materials. Here the "informal" translates to an ensemble of spaces that encourage tactical improvisation and uses not scripted in advance by the architect. The democratic quality of the space consists precisely in its availability for appropriation by a diverse group of users, which is only made possible by leaving the architecture "unfinished" and "as found." This has a profound political implication. As Saskia Sassen has noted, this sense of engagement can

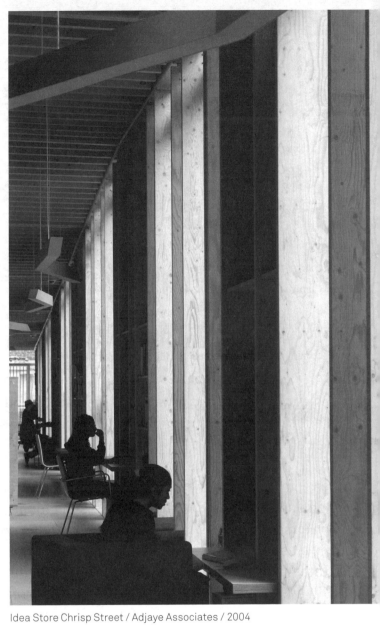

Idea Store Chrisp Street / Adjaye Associates / 2004

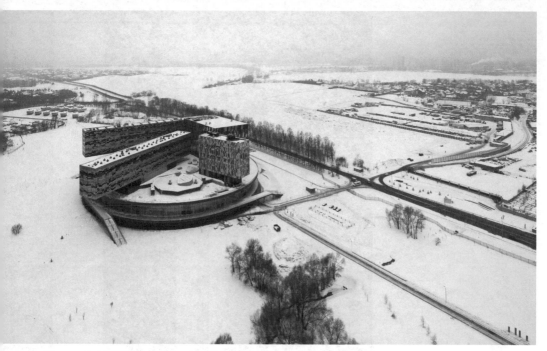

Moscow School of Management SKOLKOVO / Adjaye Associates / 2010

serve to "dislodge the privatized subjectivities our cities are producing... contributing diversity to the larger areas where they are sited."[13]

It is commonplace today to say that architectural practice is global, and in most instances what is meant is uninteresting: The impact of large multinational corporations on architecture and cities, and the overheated economies of China and the Gulf States, none of which has produced significant architecture with any consistency. By contrast, it is worthwhile noting that until quite recently, the bulk of Adjaye's work was located within walking distance of his London office. But to see that as a refusal of globalism or as a return to regionalism is to ignore the reality of the contemporary city. David Adjaye is a global citizen living in a global city. Born in Africa, educated in the U.K., and now working all over the word from offices located in New York and London, he is entirely at home in today's global culture of international exhibitions, cultural hybridity, and instantaneous communication that links distant times and places. But he

also understands that architecture and cities, unlike painting or sculpture, gain force precisely through their rootedness, their fixity in place. Working in the midst of a dynamic, cosmopolitan city, he sees no contradiction between close attention paid to the specifics of local culture (whether in Africa or East London) and the larger obligation to global citizenship.

Adjaye understands perfectly well that today it is cities where all the currents of the global economy converge: Diverse populations, fluid exchanges of capital, mobile citizens, global connectivity, and an expanded sense of time that comes with a twenty-four-hour international workday. City culture is a cosmopolitan culture in which citizens and ideas from multiple backgrounds coexist and intermingle. Cities have always been the crucibles of global exchange and the engines of international culture; they are also the prime nodes in the new global network. In cultural practice, this has engendered a shift from a hierarchical model to an extended horizontal field of affiliations. Okwui Enwezor points out that "as the idea of centers and mainstream become part of the anachronism of the cultural politics of the past, artists have oriented themselves not towards centers and mainstreams, but towards a more transversal process of linkages, networks, and diverse communities of practice."[14] And if this means empowering previously "marginal" outposts, it also means decentering the old sites of cultural power.

Political philosopher Kwame Anthony Appiah has characterized this way of thinking as "cosmopolitan," which for him implies neither artificially preserving supposedly authentic local traditions nor giving in mindlessly to the forces of globalism. Instead, he advocates paying close attention to the inevitable hybridity of a contemporary global culture that works with elements of history, place, and tradition as it takes full advantage of new technologies and the opportunities of global exchange.[15] This is a territory that David Adjaye inhabits by choice and necessity, and his projects, as they increase in scale

and complexity, are beginning to confront these issues head-on. This is why, as he moves into larger projects, with complex institutional requirements (in Moscow or in Washington), I am confident that he can retain the critical edge that his buildings to date exhibit. Although the looser, material improvisations of the Idea Store or the early houses may be foreclosed to him in these larger projects, the commitment to difference and heterogeneity that cosmopolitanism implies, to differences that make a difference, will serve him well. Like Salman Rushdie (as cited by Appiah), Adjaye has placed his wager on "hybridity, impurity, intermingling, the transformation that comes of new and unexpected combinations of human beings, cultures, ideas, politics, movies, songs." For Adjaye, as for Rushdie, this is how "newness enters the world."[16]

Notes

1. Rosalind Krauss, "Sculpture in the Expanded Field," in The Anti-Aesthetic, ed. Hal Foster (Seattle: Bay Press,1983), p. 30.

2. "This Wonderful Craft," a discussion with Aureliusk Kowalczyk, in David Adjaye, Output (Tokyo: Nobuyuki Endo Publishers, 2010), 270.

3. Ibid., p. 272.

4. Adjaye Associates, Material Table, exhibition catalogue, The Aram Gallery, London, 2011. David Adjaye introduction, 7.

5. Adolf Loos, Sarntliche Scriften, ed. Franz Gluck, vol. 1 (Vienna and Munich, 1962), 339; cited in Max Risselada, ed., Raumplan versus Plan Libre: Adolf Loos/Le Corbusier (Rotterdam: 010 Publishers, 2008), 193.

6. Peter Allison, "Materials and Materiality," in David Adjaye, Making Public Buildings, ed. Peter Allison (London: Thames and Hudson, 2006), 11.

7. Material Table, 7.

8. Ibid.

9. "Light and the City," in David Adjaye, Output (Tokyo: Nobuyuki Endo Publishers, 2010), 7.

10. Okwui Enwezor, "Popular Sovereignty and Public Space: David Adjaye's Architecture of Immanence," in David Adjaye, Making Public Buildings, ed. Peter Allison (London: Thames and Hudson, 2006), 11.

11. "The design was a critique of the Victorian Street and its insistence on a certain kind of informality, which was intended to support public life—whilst the back facades were completely informal. I found this a very compelling thing to pursue because I believed that the previous formality was no longer and accurate reflection of the society we live in, and that the schizophrenia that it represented had to be reversed." "Light and the City," in David Adjaye, Output (Tokyo: Nobuyuki Endo Publishers, 2010), 7.

12. Note the well known formulation of Leon Battista Alberti: "Beauty is that reasoned harmony of all parts within a body, so that nothing may be added, taken away, or altered but for the worse." Leon Battista Alberti, On the art of building in ten books, trans. Joseph Rykwert, Neal Leach, and Robert Travenor. (Cambridge: MIT Press, 1988), 156.

13. Saskia Sassen, "Built Complexity and Public Engagements," in David Adjaye, Making Public Buildings, ed. Peter Allison (London: Thames and Hudson, 2006), 15.

14. "The Politics of Spectacle: The Gwangju Biennale and the Asian Century," in Invisible Culture: An Electronic Journal for Visual Culture 15: Spectacle East Asia, Fall 2010, http://www.rochester.edu/in_visible_culture/Issue_15/index.html.

15. Kwame Anthony Appiah, Cosmopolitanism: Ethics in a World of Strangers (New York: W.W. Norton & Company, 2006), 101.

16. Ibid., 112; Rushdie is describing his novel, The Satanic Verses (London: Viking, 1988).

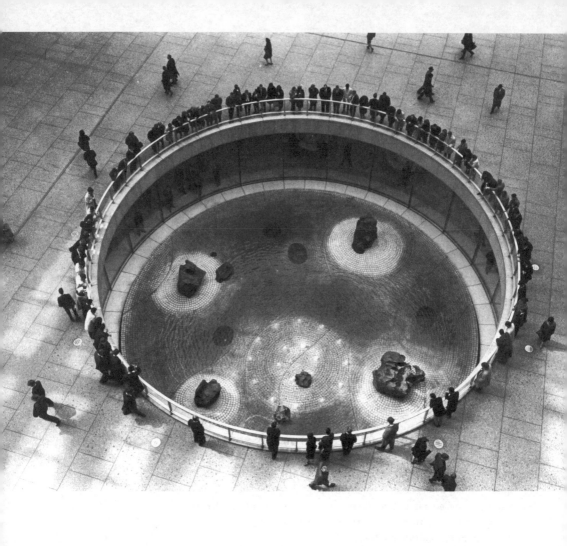

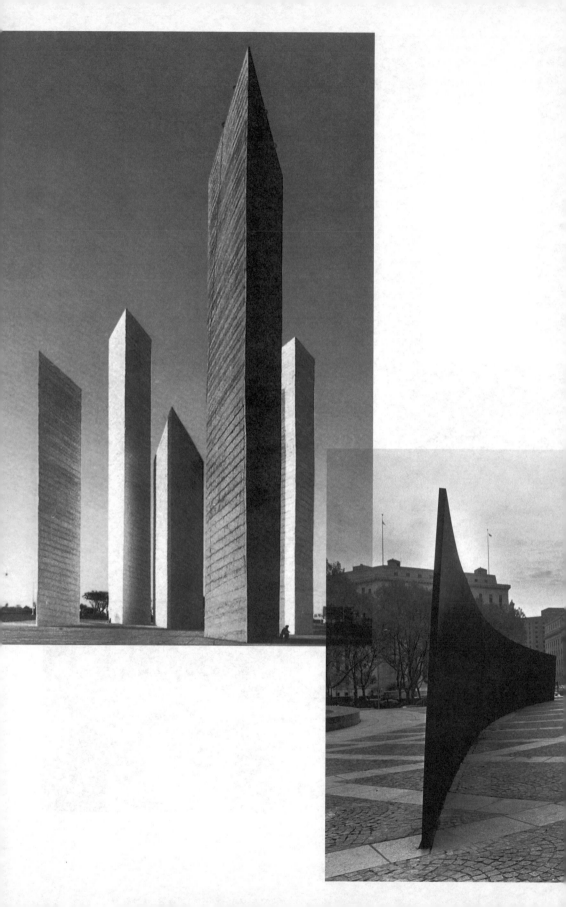

26–27, left to right

Sunken Garden / Isamu Noguchi / 1964

Terrace Plaza Hotel mural / Joan Miró / 1948

Group of Four Trees / Jean Dubuffet / 1972

28–29, left to right

Torres de la Ciudad Satélite / Luis Barragán, Jesús Reyes Ferreira, Matias Goeritz / 1957

Tilted Arc / Richard Serra / 1981

Public Space/Two Audiences / Dan Graham / 1976

Glue Pour / Robert Smithson / 1969

De-authoring systems

What I'm really interested in
is the invisible things that hold
everything together.

– Matthew Ritchie

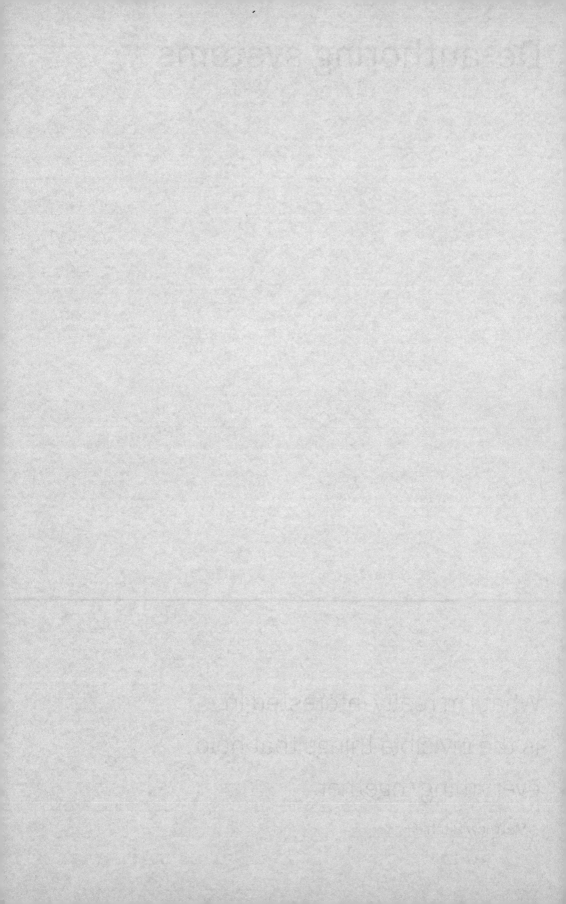

Skins and Shrouds

Matthew Ritchie, David Adjaye, Marc McQuade

David Adjaye You were the first person I asked to come teach a collaborative art and architecture studio. I wanted to co-author the class with somebody outside of architecture that I had had a synergetic dialogue with in order to see what the repercussions would be for the students.

The approach was not to enforce a strict system of thinking, but rather to create a slightly disorienting strategy. To bring in a discipline which would have a different perspective and to try and see how much we could push architecture students who have been through a graduate program to start opening their minds to other ways of thinking.

Of course, in the end, because it's a school, we always have to produce something. I hope that there wasn't too much archi-tecture for you.

> **Matthew Ritchie** No, as I remember it, our conversation at the time was focused around a number of issues that we thought were particularly interesting. One was the idea of scaling and the other was expressivity in relation to the modernist legacy.
>
> We use the word modernism very carelessly, because there are so many modern periods that go back. There's, at least to my knowledge, five or six moments of modern experience going back to the 17th century. **As a child of the postwar period I'm interested in bringing back an expressive content and form to what charitably could be called a palate cleanser for history.** Less charitably, it could be called a massive retreat from the expressive potential of human beings, the foundations for which were laid three or four

thousand years ago. In the postwar period it really was a way of rationalizing and rationing material scarcity. We are roughly the same age, and we grew up in a period of increasing plenty, but still aware of the previous era of distress, shrinkage, and shortage.

Something we talked about with the students was the idea of a scalable expressive grid. The primary material for building an expressive system has to contain its expressivity within it, whether it's a protein or an amino acid. The word expressive also probably deserves some careful attention, because it's commonly used as an antithesis to the geometric or abstract.

We were interested in talking about expression as the expression of a series of abstract principles, which can be essentially anything. It's in the complex expression of ideas that you arrive at complex results such as DNA or a tree or a human being.

I think that there's a kind of defensive language of postwar modernism that seeks to portray itself as somehow more complex, but, in fact, it's a very crude simulation of natural complexity. The kind of expressivity I'm talking about is that which is found in naturally occurring systems that are highly expressive and highly efficient.

In a sense, there's really no conflict here. The conflict is purely cultural. There's a perception, especially in educational institutions, that things are set at odds with each other. This is largely due to didactic teaching methods that are always based on "compare and contrast," or on things being in opposition. **One of the most difficult cultural legacies of the 1970s academic language in the arts is this notion that opposition is somehow a virtuous position.** If you're opposed to things, you're automatically good, which is a big hangover from the kind of thinking that came out of the Second World War.

It doesn't deracinate the idea of conflict to say that things are a part of the same system. And arbitrarily creating diagrams of opposition doesn't really get you anywhere. Unfortunately, what lots of students come out of their education with is artificial oppositions, which they then butt against each other in that sort of vague belief that they're somehow doing something important, such as art and architecture, which are not innately nor have historically been remotely in opposition.

DA No, they're actually absolutely convergent, two convergent positions. The idea of going back to a building block or a primary beginning that generates something speaks to the idea of trying as much as possible to de-author. The notion of de-authoring is fascinating to me, because at the same time as one de-authors, one is also completely authoring. It's particularly interesting in the context of the studio, which is a kind of simulation, a training exercise, where students often try to be overly expressive, because that's the only thing that gives tangible results and usually a reaction from their professors.

How do you start to formulate an approach where you can teach this type of reduction to students and also allow them to move away from the desire to be overly expressive? I'm curious about your thoughts on the students having to negotiate this idea of reduction.

MR We had an interesting reversal of roles in the process where we both agreed that we wanted to give the students a big project as well as a series of small projects. A small project is relatively easy to focus the student's mind on. It's in the small projects where you can find the basic material and build bricks out of it. But we weren't going to let them off that easily. We said, "Choose a site anywhere in the state of New Jersey that in your mind requires a radical intervention. Come up with not only the physical rationale for your intervention but also the political and environmental rationale for it, too."

35

Of course, the studio site was New Jersey, which is the only state in the United States to be 100 percent built out, and so environmental collapse is kind of its middle name. It also has radical differentiation, as it's divided into thousands of sub-governments that can't relate to each other. It's also totally heterogeneous across its surface, so you have a beautiful little suburb next to a disaster, next to a slum, next to a super-rich area. New Jersey is this crazy fractal map of the economic distribution of the United States and its environmental problems. **It's super interesting as a place, despite people thinking New Jersey is incredibly boring.**

We gave them this intensely kaleidoscopic zone to choose from, without any guidance at all, with the idea that they would intuitively look at something that was a real challenge for them. About halfway through the studio, David was more optimistic, and my role became weirdly pragmatic as I remember telling them, "You have to make this into a real buildable project, or it's kind of meaningless." In the beginning they might have been a little seduced by the idea of the art/architecture combination. Easy on the architecture and heavy on the "me" side of things.

Art objects only cohere into legibility when they have a fundamental systemic basis, like when there's an organic structure. Even something very complex but abstract like a de Kooning painting, which looks like somebody just went crazy with a paintbrush, is actually built of hundreds of layers of interlocking, tightly woven sub-structures that all relate to each other at an almost atomic level. So that's what I'm looking for in an architecture project—that every layer of every system is relating to the premise of the project at every level. Otherwise, one, you're going to get waste, so it's not going to be built, because it won't be cost-effective. And two, it won't be truly expressive of the initial condition that you were looking for.

So I remember in the studio we kind of had this back-and-forth where you would every now and then sort of try and say something to cheer them up after I'd—

DA Destroyed them!

In a way, I think this speaks to the idea that for students there is still no reality and that we have the benefit of being able to produce in the world, and have produced in the world. How do you teach when students don't yet have that sense of things in the world?

What was interesting was that in the end all the projects were different attitudes to the existing built environment. We managed to get this rich kaleidoscope of strategic positions, which were not realistic at all but inherent in the schizophrenia of architects. It's this idea of being able to somehow travel to the future, and dream about the future, even when they're not really anywhere near close to the kind of basic analysis of things that are in front of them. Architects are trained to fantasize about the future. Was it frustrating to see this production of fantasy?

MR No, some of the projects were really beautifully recuperative in their attempt. What's optimistic is that you're not necessarily going to expect people to come up with a universal solution off the bat, but you are going to introduce the idea of consequence, that it's all very well to have a recuperative idea, but if the carbon footprint of the recuperative idea is greater than the problem, you haven't solved the problem.

Nonetheless, there are approaches that can be brought in. Thinking about a brick, for example, a brick is not just a physical object. It's easy to think that, but it's also the resources needed to create the brick. What is the information system required to sustain the brick?

The brick in itself is a standard for an equation that determines the viability of the entire project from beginning to end.

When I talk about the end in terms of civilization, I'm talking about maybe a 100-year life span, from being in a foundry or a kiln to its final return to a garbage heap or being repurposed.

It's not so much a social responsibility, but more of a kind of coherence in the architectural thinking that I'm interested in. Architecture is part of this large-scale dialogue, not just with civilization but also with notions of finitude and post-finitude.

What does it mean to extend human intervention over a building's two-, three-, or in some cases four-thousand-year period to sustain that kind of perspective? Are you willing as an artist or an architect to take that on, or are you really just looking for a cheap fix?

If you're just looking for a cheap fix, it's a product to solve a short-term problem, but social currency will evolve, and your product will soon be obsolete. To make a poorly designed building, knowing it's going to outlive its alleged lifespan, is perverse and sad. Why don't you just make a great building that can be a one-hundred-year-old building?

DA I think it's absolutely brilliant that an artist is thinking in a post-finite way, because ironically for architects, we are the ones who are supposed to be the inheritors of that infinity idea. We're supposed to think beyond the immediate, and we've become so consumed by a modernism which is based on consumption that we've dropped the notion of, I think, the core of the discipline, which is exactly what you're talking about.

It's interesting that you speak so eloquently and so precisely about such an issue as an artist and that I don't know of any architects who think like that. It's almost like you embarrass the profession.

MR That's not my intention.

DA No, I mean that in the most positive way. It's a really important systemic discussion to be had, but seen to be too difficult to deal with. There is a kind of premise of what I call spectacle architecture. The sort of architecture of cutting wool that we've all become completely complicit in, which is a short-term enclosure, a thinner system, and then generics.

Even the generics that are being produced I wish were real generics, not generics of the Georgian period or the Victorian period or of a great vernacular in any kind of fantastic group, but instead we have generics of the absolutely lowest common denominator in terms of production of any cultural aesthetic value. We haven't even developed a beautiful generic.

You would think we would have incredibly expressive buildings everywhere, and we actually don't. It's become absolutely fine to display your lack of knowledge about the nature of aesthetics and the nature of building or even to get anywhere near the notion of understanding that there might be an inherent DNA in something that might compose a way of actually conceptualizing something that is creative.

MR We all have to take some share of the blame. **The notion that "Nothing's going to last, so why build anything to last?" is a very odd psychosis that grips Western culture.** We know it's unsustainable; therefore, we'll make sure it's unsustainable.

Marc McQuade In that mentality we've lost the notion of patina, the idea that something wears well.

DA Right, the idea of material weathering is completely lost.

MR It's a failure, basically.

MM There is also an alternate approach, which is to design a building's demise. A short-term building with long-term thinking.

The other pivot in my mind would be something like the economy of Buckminster Fuller's super-lightweight structures.

DA **The problem of Buckminster Fuller is it's just not that much lighter than a normal building. It was a fantastic discourse about the emancipation of technology, but it's absolutely rubbish.**

MR The worst part is that there are thousands of occasions where super-lightweight temporary structures are entirely appropriate, and they're never used on those occasions. FEMA in New Orleans, for example, brought in trailers. They didn't find tents, because people don't want to live in tents; they found big heavy trailers. And the U.S. military builds big, heavy bases.

You used that word skin earlier, and it's a tremendously relevant word for students, because we do see a lot of skin-ning. What's missing is a systemic understanding of the idea of a skin.

Skin is an organ on the body. It's functional. In contemporary architecture, it's ornamental, so therefore it's actually wasteful. So you're not building an efficient system in the long-term. It's like a person wearing a suit of really shitty clothes. They don't work and they're just going to tear them off. We should come up with a new name for it like shroud, which more correctly identifies its fate. **It's like wrapping your furniture in plastic so it doesn't wear. It's deeply wasteful. The skin is thought of as a screen over which one can project their fantasies, as opposed to being a heart of the tectonic structure.**

DA If you were teaching in an arts studio, would you be talking in exactly the same terms?

MR I try to get art students to identify the building blocks of their practice. What I'm really interested in is the information brick, the constant, which is the functional brick of all creative practice.

It's like, "What are you building? How are you building it? Are you understanding that it's part of a larger systemic set of exchanges, and, if so, what is your degree of agency within that?" There's much more emphasis on agency in the arts than there is in architecture, often to the point that it's grotesque encouragement of an individuality that isn't actually there. Today an artist running a successful studio is going to have a lot of assistants working for them—it's often something like twenty people. It's just like an architecture studio.

DA It is.

MR Everything is done very carefully, very methodically, to give the illusion of total spontaneity and individualism. It's a kind of de-authoring process, but they are going to insist on pure authorship.

MM The studio began by having the students define a building block, or primitive, that was then aggregated and deployed at larger scales. This is also a strategy that you've deployed in your own work. Could you speak about this technique? What makes a good primitive?

MR This was three years ago at the height of the craze in algorithmic computational systems, which has died off a little bit now because the software got easier to use and people realized that everyone could do it.

What David and I share is that it's not just about creating an interesting primitive, but it's the position that you adopt by building your first building block You have to ask a lot of very serious questions about yourself. This is where it really

interests me. We tried to engage the students in this, and I think it really shows.

You could be saying, "I want to build a building block that makes money." Then you could go to work for Goldman Sachs. There's nothing inherent in algorithmic systems. It isn't inherently good or recuperative or human, even.

Nature consists at its most basic level of a very small number of fundamental particles, and an even smaller number of fundamental constants and energies that form these particles in what we call the physical universe. Those are the true primitives. Now, what you choose to do with them, many, many, many scales up the system from that point, is key as a human being. We have positions of authorship, and we have positions where we are not authors of our physical reality. Your actual range of choices is quite small given the time and place that you find yourself in.

The choice of a primitive becomes much more than just, "Well, I'm interested in solving a medical problem." It's more about, "There's too much Prozac in the drinking water. I'm going to make a toilet that gets rid of it"—which would be a great invention. Every single drinkable potable water source in the U.K. has Prozac in it, because people just pee it out. What would be a great thing is to design a toilet that filters out toxins before they get to the watershed and turns them into something beautiful... music for your iTunes! That's where you begin to have to redefine what it means to be an ethical thinker within the ethics of a profession. You have to consider its real ramifications at every level.

DA You've talked about relationships to the fundamental nature of things, but I wonder if there's any speculation about disposition. The studios are coauthoring strategies that students pick up to learn how to get to the essence of things. With that there is this notion of the re-authored product that results. I'm curious what your language around the notion of

re-authoring is. Is it a way of allowing a fundamental ability to create more or to be free from certain constraints?

MR Something went really wrong in the second iteration of the Bauhaus. Somewhere around then, the notion of collaboration became instead an opportunity for posturing against other disciplines. Or, later on in the 1960s, you have someone like John Cage who did random coincidence. It's not even seen as a collaborative exercise but rather as five people doing five cool things at the same time. What you get from that is only 20 percent of each experience, and it's hard to know historically how we could reinvigorate that.

I use the word "collaboration" a lot, but I prefer the much simpler idea of "sharing," which is a nice old-fashioned word! It's amazing how much more there is to go around than if everyone has to have their own shit. Suddenly, there's not enough for anyone, even though there's the same amount of stuff in the world.

I think that's kind of gotten lost in educational institutions, as well. It wasn't present when I was at art school. It's not present when I teach now.

MM Do you think that mindset is any different in Europe than in America?

DA American education over the last thirty years relied heavily on the premise that if you dove into the scholarly position of architecture, you would find a fantastic natural evolution and move forward. In Europe, what happened was there was a complete abandonment of that sense of wanting to investigate the future of architecture through the academic discourse of the past.

In one way, there was a resurgence back to the fundamental question of "How do we build now?" That happened throughout Switzerland and even in the north and down to the south. From

that, other questions arose. What then does making something together mean? What does it mean to be together? What does it mean to actually have a neighbor? All of these questions start to play into it, and that's been a huge area of discourse which is now folding into "Now what do we do with systems?"

Let's be blunt about it. There is not good architecture happening in the U.K., and there probably won't be for the next three years. The golden period, which is an agenda of regeneration through making and culture, has been royally switched off. We're back to a universe of political and social agendas being driven by fiscal ones, and that's the grip of Europe.

Unfortunately, it's a cancer all over Europe, so architecture has a very difficult position now. I think America is in a traumatic place where it's not sure where it wants to go. I sense camps that are interested in the European paradigm, and I sense camps that are interested in a much more hyper-theoretical jump to a new paradigm, to just flush everything and remake the universe again. I'm suspicious of both.

> MR It's hard to build a solo reputation on the premise of sharing. In reality, Ninety-nine percent of what is built is the same stuff, everywhere. The academic discourse around it doesn't seem to matter. Seventy-five percent is generic replacement housing stock, and twenty-four percent is corporate junk, and then there's one percent out there for exceptions.
>
> Models of living can be put forward, but I think that the tragedy is that there's been a real failure to articulate how successful projects that don't necessarily have an author can be modernized. There's a tendency to locate something as either a historical model that has to be perfectly recreated in every detail, or it has to be completely abandoned with a kind of radical new substitute.

It's like, "Well, that was weird that the whole city of Bath was so cool, but there is nothing to be learned there. It was just a weird one-off."

DA But I would throw a curveball just into that Bath thing, because Bath did develop something which I think is fascinating to what we're talking about, which is the notion of a generic.

The Georgian generic as a kind of blueprint for making a city was quite powerful, and it basically set up a simple system of non-exceptionalism and a uniform of very well studied proportional buildings, which was about efficiency, health, light, buildability, and a certain kind of elegance and use of material that was local.

MR Exactly; it's a highly effective system if you take away the "Bath-ness" from it. It's an industrial city built to give people jobs and sanitation and reasonable amounts of light and air inside with a kind of synthetic system. That logic can be applied to any aesthetic system, but, instead, the lesson is learned that if it doesn't look like Bath, no one will like it, which is the exact opposite of what it should be.

Then there's the modernist overreaction, which is, "Therefore, we'll have to be in opposition to that. We'll have to make it really highly aggressively modern, even if it's inefficient." It becomes an equally aesthetic position.

MM In your mind, is there anything worth taking from modernism? Are there any positives?

MR My argument would be that modernism began in the 16th century. Cities like Bath are inherently modern, and it's just a series of aesthetic vocabularies that could quite happily coexist with each other. That's the shared space that architecture should be occupying, and essentially what should be exiled from that is failure. The canonical explanation of architecture that fails is it fails functionally, because

45

if you include everything that works functionally, you include an enormous variety of physical forms and systems.

What you begin to exclude is bad track development housing, and garbage commercial development with fake skins, which constitutes ninety percent of what's built today. This notion should be consistently included in educational discourse so that at least architects come out and make a case to their clients like, "You know, you're building something that's not only ugly but stupid. It's not an investment when you think of the cumulative value."

Clients are not insensitive to the idea of investment if it's phrased correctly. It's much different to own the Lever house, which is a highly desirable investment property, as opposed to the skyscraper three doors down, which is on the same block, which nobody wants to buy, because it's a piece of junk. So it's not an impossibility to convince a client that properties are an investment, especially when they're buying the land.

Part of this is about building into the DNA of the student from the very start a perspective that underscores long-term thinking. "This is a long-term game, and a lot of pressure will be put onto you to make short-term decisions. You will find it easier sometimes to give up, but neither you nor your client will win by making this supposed cost-efficient sacrifice, because there's always a more cost-efficient way that's also within a prior architectural system that's better than some junky system that somebody just dreamed up."

DA I love the idea that you've just put out there that we should move away from the visual power of 20th-century modernism and its infection of us as the only image of modernity, and expand modernity back to the 16th century.

MM Right; there should be a catalog of the multiple images of modernity.

MR Exactly; it's fascinating. Today we have faceting, and five years before we would have had blobs everywhere. There should be a vocabulary of forms, which is something that goes back to Victorian modern architecture. You have these catalogues of forms that are tested and trusted.

In that era, nobody really cared if something was straight or curved, as long as it did the job. They loved trends and fads and fashions, but they were much less convinced that the latest fashion was actually an advance and progress, because underneath they were a much more modern culture in some ways, in which everything had to be really functional. They were building lightweight, quick structures all the time like railway stations, and they wanted to build as fast and quickly and cheaply as possible.

DA Absolutely. The premise is all about the efficiency of the generic. I like your use of the word "sharing."

MR It's like Communism, basically. I love it. It's no longer "Who are you against? What's the con? What's your angle?"

MM Sharing, an alternative to the older kill-the-father generation.

DA The kill-the-father tactic is actually just boring to people, because it smells a bit unauthentic, and I think generations sniff authenticity. They know that it inherently has a bad bullshit agenda in it.

MM Do you think this mentality will resurface in the future?

MR If you look at it anthropologically, the baby boom cultivated this position of oppositional strategies, because it was the most crowded time in the world. This was the biggest generation, so people grew up having to elbow other people out of the way. One way or another, they all have the same

need to constantly find themselves in opposition to and better than others of their generation. They grew up seeing their parents with little, but by the time they arrived there was a kind of post-scarcity and they got their chance to grab a lot. I think it may be as simple as the fact that all the classrooms were crowded.

The baby boomer generation is not like the previous generation, which thought, "I get old and die." These people think they should live forever. Stay in power forever; be in charge of institutions and public dialogue forever. They'll get more paranoid as their trust funds diminish and shrink. It will be quite remarkable. And they've got to look good in extreme old age. Imagine the Red Hot Chili Peppers in their retirement. That's how they're going to have to see themselves. Oh, cool, wheelchair races! Special oxygen with little gold flakes in it.

It's going to define the architecture of the next twenty-five years—that's where the money is, and that's where the clients are going to be. They're going to want to buy immortality, and they can either buy it with a very hideous, gigantic tomb or we can try and construct a discourse that allows the idea of sharing to permeate before it gets to that.

Matthew Ritchie

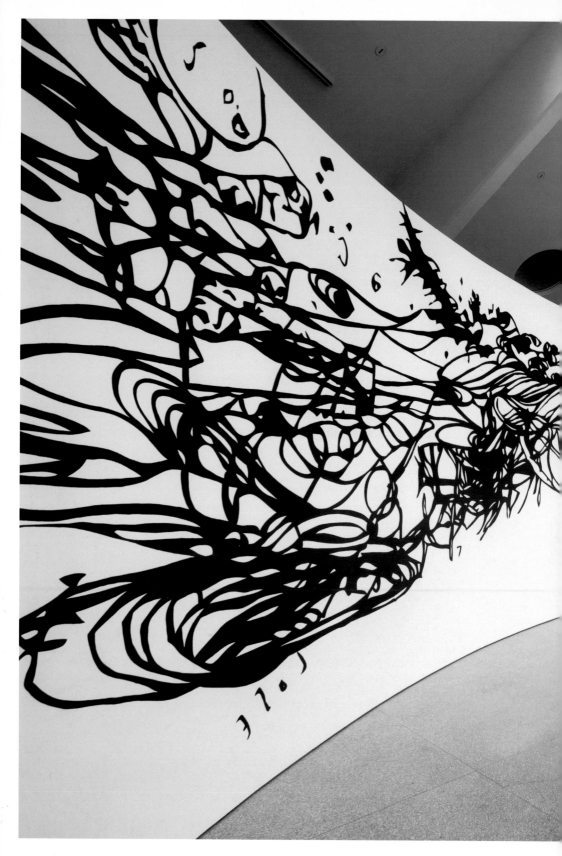

50

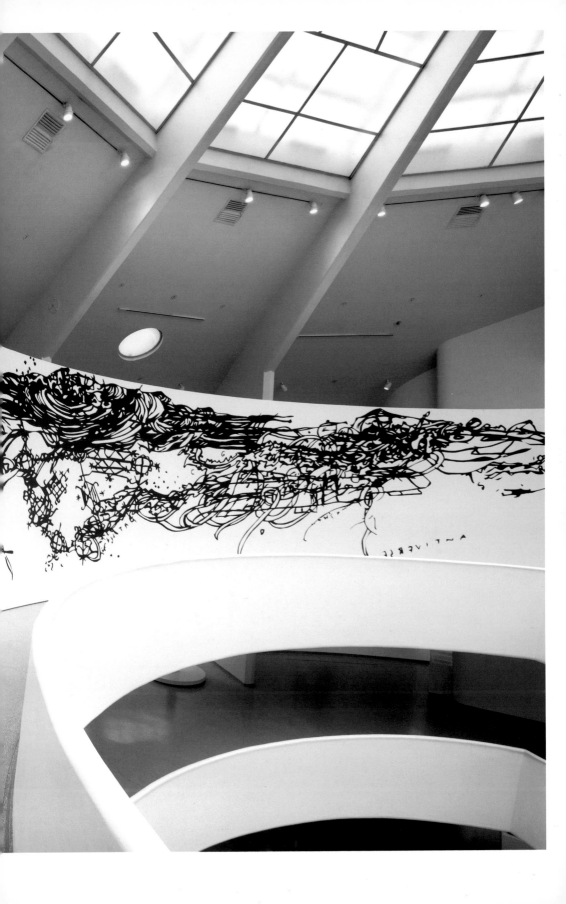

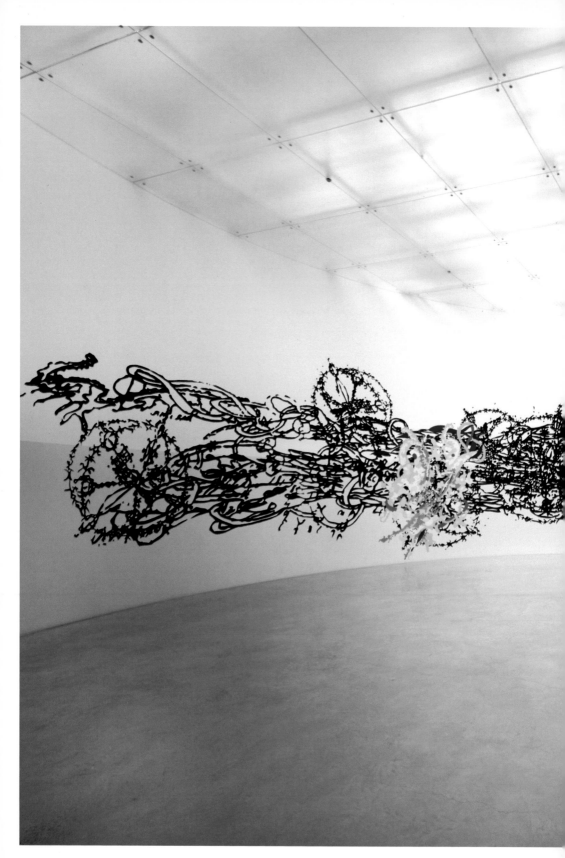

52

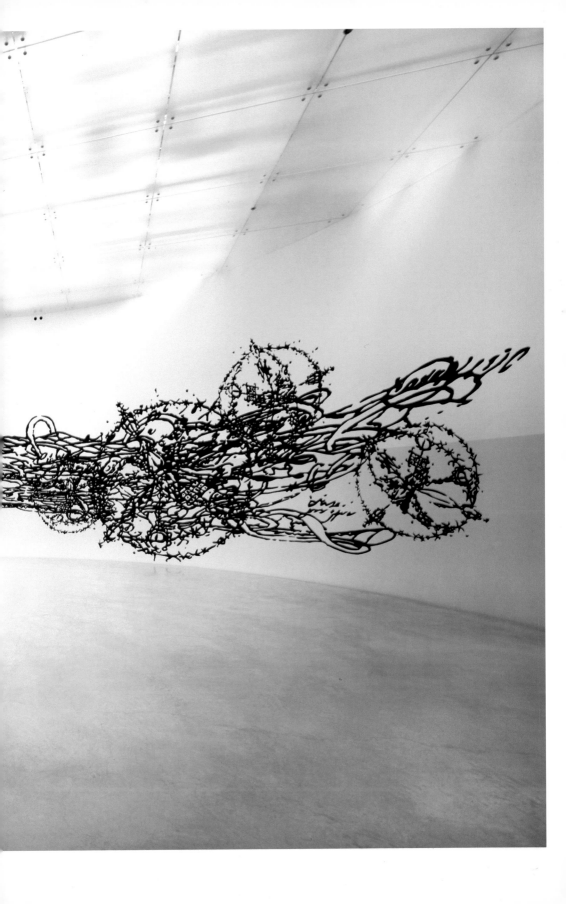

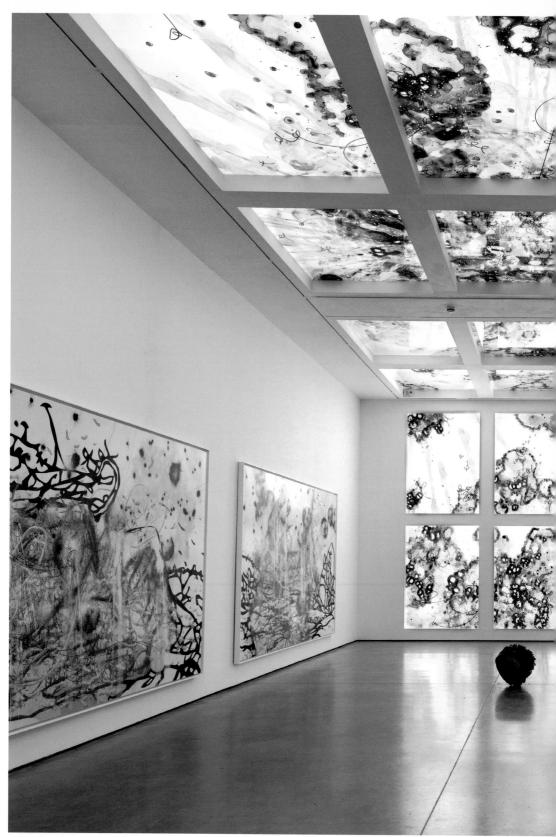

54

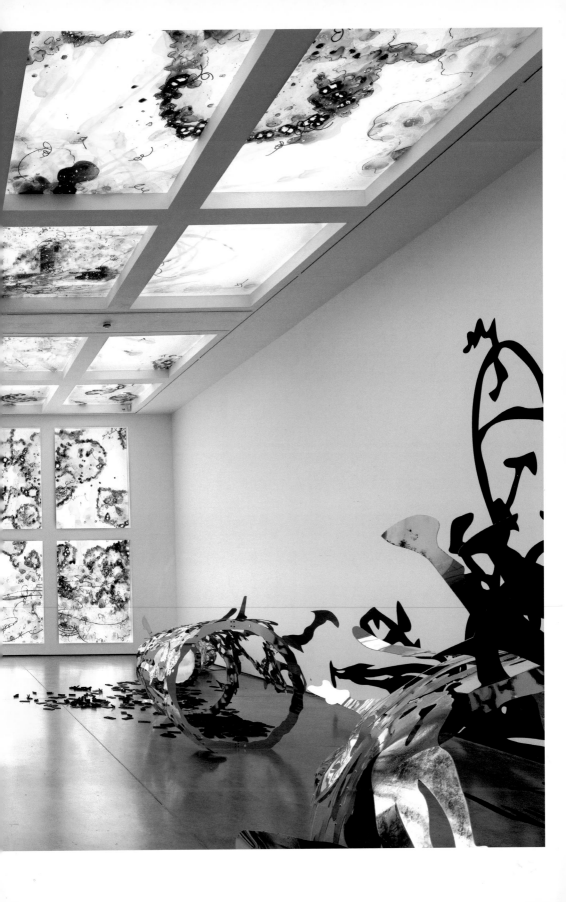

56

60

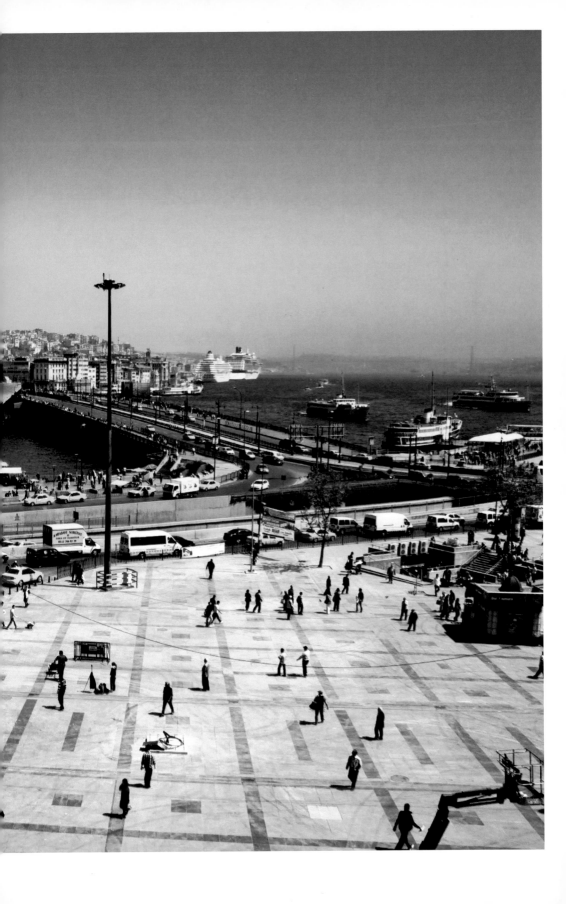

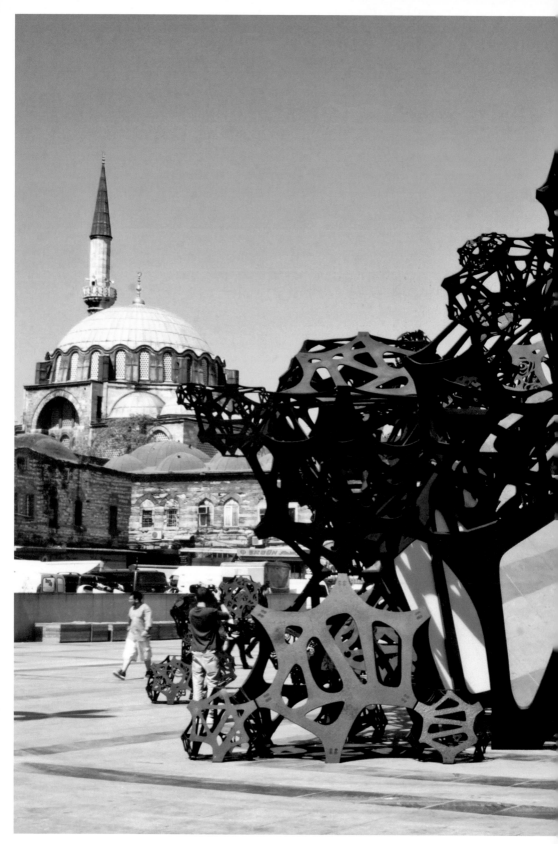

MIT - Zeign Sports + Fitness Center - And Kevin Roche

Systems Theory

Sanford Kwinter

Among the prominent developments that have marked recent art has been the incursion of "method" into the heart of what has long appeared as an array of miscellaneous, even random art practices. By method, I mean nothing more than an approach in which a certain discipline is sustained over a range of executions, sustained, that is, long enough both to leave a trace of "system" in the deposited production and for that systematic quality to serve as a principal rhetorical feature of the work. In contrast to the more circumscribed and puritanical routines we saw set in motion by the American Minimalists of the 1960s and '70s, much current work remains rooted in identity production—the inward, capricious, ego-particular idiosyncrasies of slacker-generated and decidedly untestable "theories." While there remain practices of enormous power at the cool end of this spectrum (the enterprising yet sober and disciplined engagements of Studio Olafur Eliasson are a principal example), there are also emerging a number of art-cosmology practices that make reference to historical positions and campaigns—those of Buckminster Fuller, for example, and Archigram or Futurism, etc.—particularly to their imaginative components and less so to their (non-art) rationalism. Weirdest, and most notable, is the inexorable drift of much artmaking to both the domains (the city, unsentimentally defined public space, building- and world-scale interventions, infrastructure, interiors) and the mental habits (geometric, algorithmic, behavioral, systematic) that have increasingly characterized design theory and practice since the advent of digitization and globalization. The boundary, and necessary distinction, between art and design is one that has lately been defended with unexpected vehemence, in notable contradistinction to the foundational work of post-Minimalist theory that once successfully sought to invigorate art by espousing the range and

scope of ambition that had till then been the sole province of the architect (and which is a prime legacy of the early October group). If such defenses today have started to border on the strident, it is a sign that the boundary—for better and worse—is being lost.

Somewhere amid this tangle of incomplete emancipations lies a great deal of the work that we call emergent today. A prime example is Matthew Ritchie's current traveling—or is it self-replicating?—project, a series of structures including, most recently, The Morning Line in Seville and The Dawn Line in London (now on view in New York). An earlier, scaled-down iteration, titled The Evening Line, was presented at last year's Venice Architecture Biennale, with the larger, more expansive and centrifugal Morning Line following soon after. This trajectory itself is a sign that Ritchie's work has found clear and unapologetic interest among architects, but, more germanely, Ritchie himself developed, resolved, and realized these structures only with the collaboration of Benjamin Aranda and Christopher Lasch, two young researchers who specialize in algorithmic design. While The Morning Line initially appears as a snarled tumbleweed of metal filigree accidentally forming both interior and exterior cavities for inhabitation, as well as the structure of transfers and arches necessary to keep it stable and upright, it quickly resolves in one's perception as a pattern of modules that is rotated, displaced, and scaled at every level and along what appear to be determined paths. This is the moment when an underlying predisposition is sensed, which transforms one's understanding of the work (the modules, in fact, are hand-generated cartoons that are computationally "grown"). Ritchie brought to the table a taste for medieval knowledge systems and the dream of their comprehensive resolution within a pageantry of materials and narrative characters. His interest in the figures or actors of knowledge as points of compression of historical understanding and imagination, or simply as convenient ways of presenting these to the mind, belies a profound belief that the world encodes itself in

its productions and that this code represents an asset and resource that could and ought to be tapped, if only we knew how.

On the one hand, this is not something you can make "sense" of. It is largely a framework of heroic delirium, not too different from the cryptic scenography played out in Marcel Duchamp's *Large Glass*, only here writ across the universe, across all space and time. Yet it is also disturbingly reminiscent of the derisory project of Edward Casaubon, the sterile, deluded figure at the center of the first half of George Eliot's novel *Middlemarch*, whose dream of a "key to all mythologies" is shown to be little more than a pedant's need to impose order on material in the flagrant absence of living concepts. On the other hand, Ritchie's world theater marks an unmistakable commitment to the principle of a matrix or diagram that makes form (or space) and information into a single continuum. I hesitate to see a mere continuation of two decades of cultural eclecticism in this tendency, but rather see in it—at least perhaps—the provocation one might have felt before the mystery of Isaac Newton's predominating interest in alchemical transformation during the three most (scientifically) productive decades of his life. Ritchie's interest in painting as a language—that is, as a writing in and an embedding of world into form, and decidedly not as only a signifying element in the semiotic sense—that espouses the logic and procedures of film, as well as of music and, yes, of nucleic acids, is as profound and potentially pro-ductive a delirium as any in our time. That Ritchie sees these all as "information structures" and seems to understand that there are "efficiencies" within even phenomenological experi-ence that can be tapped with mathematical, or at least regular, devices, turns out to be the very sobriety that saves him—and just in time. With the collaboration of Aranda and Lasch (and the Advanced Geometry Unit at the engineering firm Arup), the glyphs of free-form writing/drawing that typify much of Ritchie's work are captured within "virtual" modules (the digital-mathematical scaffold supplied by Aranda and Lasch), then manipulated with the help of formal instructions (code,

keystrokes, and so on), just as such instructions have, over the centuries, become embedded into the syntax of natural languages to be deployed with every speech act. Through its expression of variation at all levels (scale, orientation, density, number, etc.) and in every combination, the project becomes an inchoate study in the syntax of pattern, offering the possibility to see in the world what Sergei Eisenstein, in his early days, asserted for film: that everything—i.e., meaning—happens in the conjunction of frames, in the in-between.

Ritchie will reproduce and transform *The Morning Line* in a variety of locales, including Vienna in May 2010 and then New York in September, and each work in this line—or phylum, as it were, should one wish to press the evolutionary metaphor—represents a kind of performance in which a score is reanimated within, and in response to, a given set of spatial and temporal conditions (variations in physical and social site). (This posture could hypothetically be strengthened to include the specific historical conditions of place and time and their nontransmutable meanings. Though it is not in Ritchie's worldview to do this, he opens the possibility of a practice that would.) There is an undeniable experience of beauty and lyricism as one surveys the work, generated by the dislocations one cannot help but discern and play with within one's own internal rhythm section, between the beats and syncopations of the absent but insistent (because virtual) modules and the glissandi and arabesques of the drawn lines in aluminum that are all one literally sees. To begin, this provokes a different habit of seeing—different at least from what has become routine in the media and art worlds—in that it is a type of what Theodor Adorno might have called structural seeing, which reads primarily the generative formations that underlie appearance. Second, it introduces a new type of object into our world: Environmental but not burdened by rationale and utility as would be a standard work of architecture; logical in its propagation and organization yet also in a state of magic compression, like the cosmological constants that characterize at once the universe of the late-medieval cosmologist Nicholas of Cusa and the contemporary

"scientific" universes of string and brane theory. These cosmologies are in one sense no more coherent or less arbitrary than, say, the ever-expanding universe of the fictional Pokémon legend (a world that is relentless in its commitment to evolution yet that is also now endowed with papal benediction), and they are certainly closer kin to today's omnipresent RPGs (role-playing games, generally video games) than to the masterworks of the panoramic novel that figured so strongly as cultural references—and as philosophical and aesthetic guideposts—as late as the 1980s. If playing the role of primitive or naive "seer" or visionary and cosmologist has become a legitimate posture for contemporary artists, it may, ironically, be a symptom of the recent wholesale abandonment of the will to theorize in systematic fashion in the first place.

Yet here is where the ethos of that interloper "design" is beginning to play an increasingly prevalent and enchanted role within some contemporary art practices. Although it will initially appear unsophisticated to say so, the reality of adding a certain modicum of formalist reflection to the production of objects and environments in today's largely individualist and nombrilistic art practices has been no bad thing. (Think preeminently here of Thomas Demand, whose practice serves as a beacon in the darkness.) Design thinking, especially over the past decade, has become an increasingly trenchant and analytic practice of engagement with economic, technological, and sociological developments at virtually every scale. Part of its newfound responsibility to think and rethink the modern environment in its manifold crises—urban, economic, technological, natural, and, yes, anthropo-ecological—is indisputably a principal factor explaining its recent transgression into certain areas of art practice, most notably, the physiological aspects of perception. It is interesting to see how the sometimes guileless utopian movements of 1960s design milieus have begun to form a massive bloc of reference and a historical anchor point for some contemporary art practices, such as those of Tomás Saraceno, Carsten Höller, Ai Weiwei, Tobias Putrih & MOS, and even the whole mongrel pack of relational-aesthetics producers.

The crisis of art, long forecast by Marxist critics, albeit during moments when such cries carried little convincing power, has indeed arrived in our midst, and it is, as the best of them (Debord et al.) prophesied, a crisis of experience, not representation. The crisis was brought about not by philosophers or cultural producers, and not even directly by economic developments (not, that is, in the predictable "vulgar" sense), but by the transformation of human communicational and even epistemological (knowledge) ecologies, the direct product of, at once, a society given over to the cult of automatic processes and a populace exiled from the reasons and realities of nature.

In works like the (endless?) suite announced by *The Morning Line*, one may well glimpse not only an open world but perhaps a new way of working and thinking, one in which imagination and science, method and caprice, the sociocultural and the natural, are inseparable and no longer subject to the scolds and disciplinary distinctions that seek to protect the sanctity of artistic practice even if such protection will surely destroy art for good. Art's occasional but growing fascination with design methodology and thinking is partly a recognition of an ancient but unacknowledged complicity and partly a dawning recognition that the problems and issues that matter today are presenting themselves at a scale, depth, and technicity that art can no longer afford to ignore—nor can it remain entirely reliant on its own history, or on its stale commitment to irony, as a guide to action.

Sharing Our Skin

Matthew Ritchie

For the last several years David Adjaye and I have been discussing "Just what is it that makes most of today's buildings so similar, so unappealing?"[1] How can we contribute to a different kind of building system, one that contributes to the built world and the production of knowledge? In contemplating this kind of practice, numerous catch phrases come to mind: Generative, recuperative, collaborative, interdisciplinary, relational, hybrid, crossover, pluralist, cross-cultural, post-colonial, post-black, and post-white. None are quite right. The right word for practices dedicated to full participation in the forthcoming super-positional state is a simple one: Sharing.

It certainly sounds like an old-fashioned idea. But to share is not only to give but to receive. Building systems that share effectively must share more than efficiencies of scale and energy; they must share strategies of meaning. In our experience teaching together, David and I have frequently emphasized the need for large-scale solutions grounded in specific materiality over ideology. The organic aggregation that characterizes spaces suitable to sustain human meaning does not happen through master planning, pastiche, faux-iconization, or disguises. Rhetoric is always defective when confronted with reality. Markets and exchanges, civic, corporate, and criminal, define and defy top-down edicts of spatial resourcing. Cities have not speeded up; they have slowed down. The core modernist argument, that individual creative expression should conform to the efficiencies of human technology, is no more plausible than stating that it would be more efficient for humans to regress to the mats of bacteria that colonized the early seas. In a 12-billion-person world, we need a new strategy. Fortunately, a new state is emerging from the informational

chaos—one that we can perhaps frame more closely with the chimeric word "superposition," a term borrowed from science.

Despite Richard Hamilton's presciently postmodernist work of 1956, post-modernism crashed at exactly the moment its skill in challenging ideological conformity would have been most useful. Robert Venturi's second book, <u>Learning from Las Vegas</u> (1972), proposed a client-based structure for postmodern architecture—a tango with the global oligarchy under the guise of renewed social meaning, followed by a compensatory academic crouch. Almost contemporaneously, in "Sculpture in the Expanded Field" (1973), Rosalind Krauss defined postmodernism in the arts as cultural terms held in opposition, among which were landscape, art and architecture. Even after the expansion of the field of post-minimalism, artists were rarely to be found in the precincts of architecture schools.

We can superficially trace one cause for this alienation to the rival programs implied in Krauss and Venturi's models. A softening of the terms of postmodernism rapidly solidified during the final collapse of the Cold War order and introduced us to the so-called "End of History." Influential art works that deployed surrealist dream language inside the formal terms of post-minimalism and pop marked an evolution away from social meaning, like their parallels in the architecture world. Today this work can be more properly understood as "multi-positional" instead of "oppositional," and conforming to the first stage of Vattimo's "Three Deaths."[2] Over the same period, the public face of postmodern architecture devolved into iconic expressions tacked onto prefabricated frames, in a succession of short-term gestures defined by their introverted relationship to the history of form rather than social meaning. After 1989, the artists of "relational aesthetics" quickly sketched a world in which works were "in constant dialog with the context from which they reproduced." But relational aesthetics could also be described as a variant of multi-positional practice with one significant inversion: Its positions are occupied in relation to

landscape and architecture, and occupied solely through an immaterial gesture.

By 1995, the evolution of human and non-human computational and information systems expanded the field of cultural production still further and relocated the center of urban focus from the *dérive* and the *feuilleton* to the flash mob and the smart phone. Any single artist or architect trying to demonstrate or understand the underlying nature of their own "expanded field" had to consider their practice in terms of every possible position that could be mediated by computational space, a space particularly absorbing and recursive for architecture. Computational space itself has no meaningful aesthetic, only a series of nested workspaces and filing systems, whose overall appearance is the haphazard result of legacy coding and commercial guesswork. Like the façade architecture Venturi describes in <u>Learning From Las Vegas</u>, its relationship to meaning is transactional and highly degraded. Since 1995, "public architecture" has all too frequently deployed the idiosyncratic façade systems developed in computational space draped over structural distribution systems, not to locate or create "place," but to facilitate brand recognition and ease of use.

That the key forms of social interaction that might be mediated through the large-scale structural relationships of art and architecture had been reduced to a gesture in front of a façade was poignant. It occurred just as computer aided design systems began to offer the most precise and authentic method for perpetuating an individually expressive mark or gesture over a large-scale system. But a side effect of embossing or "tattooing" buildings, screens, clothing, and people has now subtly permeated both the art and architecture worlds, opening up the possibility of the return of the renewed social meaning of the information tattoo—exactly what prompted Adolf Loos to write "Ornament and Crime" (1908).

The skin, the primary human system for communication and homeostasis, is of course a key concept in understanding both the façade and the gesture. Just as surely as skyscrapers are not social spaces, curtain walls are not skins, dynamic systems in constant dialogue with their context on every level from energy exchange to communication. In Patterns That Connect, Carl Schuster documents the tattooing of a Tupanimba warrior as directly representing the number of his kills. In the contemporary Russian mafia, spiderwebs and skulls serve exactly the same purpose. The concept of the skin can not only be directly linked to the patterns of intergenerational meaning and biological communication Schuster collates, but also to Latour's metaphysical ontology of actants, irresolutions, translations, and alliances, all grounded in the concept of sharing human and non- (or trans-) human space. Skins are social organs, creating and embodying the same intergenerational, communicative, and metabolic building systems and drivers that constitute their interiors. The reconsideration of the building skin in numerous contemporary architectural practices has had extensive parallels in the art world in both projective and embodied works. In Shelley Jackson's *Skin Project*, a story is tattooed onto the skins of 2095 volunteers, one word at a time.

Even as one very old mode of sharing—the performative skin—has returned to architecture and painting, another entirely new phenomenon has emerged to claim our attention and compel us to reevaluate the meaning and boundaries of the very idea of sharing.

In 1995, a team of scientists produced the first physical example of a Bose-Einstein condensate, a bizarre fifth state of matter in which atoms are held in multiple quantum states, physically superposed not over but within each other.[3] In this esoteric material, all atoms share the properties of all other atoms while also retaining their own identity. This is a sharing beyond culture, beyond skin. The definition of information as not only comparable but directly transposable to a physical

state has also arisen in a series of laboratory experiments conducted in 2010 physically creating Maxwell's demon, eradicating four thousand years of debate over whether "form" and "content" are the same thing—namely, information.[4] Not only are they a unitary concept, but at low temperatures they are super-positionable and therefore do not enjoy any inherent oppositions at any scale. In thermodynamic terms, the information universe operates at exactly the right conditions for this to occur in information systems today. Ginestra Bianconi and Albert László-Barabási have comprehensively described the architecture of such complexity and how the condensation of computational networks can be physically understood as the informational equivalent of a Bose-Einstein condensate.[5] Through the medium of computational space, a final state of total information and cultural condensation becomes not only possible but inevitable.

Although this super-position has not yet been fully realized, we can see it coming in every aspect of human relations. In the 21st century—all appearances to the contrary—everything will be shared. Although income inequality is rising, so are sea levels. Although fresh water for consumption is more widely available than ever, so too is contamination. Every person in the U.K. drinks antidepressants recycled through the shared sewage system. Although the quality of individualized human violence is decreasing, the quantities of institutionalized brutality are increasing. Although exports are growing globally, importation of invasive bio- and civic systems are too. Although the financial system is distributed unequally, its risk is still distributed among all. Although the political spectrum may be superficially polarizing, it is only following the power law of all spectra. The Manichean dynamists of the last century have already given way to the community organizer and the corporate strategizer, neither of who believe in a bipolar world—only in different forms, systems, and ownerships of distribution. If standard thermodynamics, with its explicit demands of conservation and efficiency, was the physical model of both

modernism and postmodernism (which simply placed compet-
ing local thermodynamic systems in opposition), perhaps this
fifth state of matter can serve as a model for our evolving world.

The question is not whether to share, but how to share produc-
tively. New systems of sharing, such as super-positionality, and
old ones, such as genuinely performative skins, will define the
result. Created systems that rely on mandates and externals,
whether oriented toward Hegelian truths, Zion, or commercial
 efficiencies, will fail. Only created systems like skins and
super-positions, which distribute and recognize information
and materialization through something like Latour's networks,
have the potential to occupy multiple meanings in the forth-
coming super-positional state. Without constant updating and
correction of legacy viruses not even our much vaunted "infor-
mation culture" will survive us. The paltry fifty-year lifespan
typically demanded of contemporary built structures and the
less than fifty-year lifespan for every ever artwork produced
using video, plastic, glue, or lights both speak to a highly prob-
lematic relationship with sharing over time. If our next buildings
and artworks do not participate in that sharing, they will be
as swiftly outdated as the "ornamental" systems Loos once
decried, but lacking even the sentimental attachment we place
on such historical artifacts. Tribal tattoos and Art Nouveau
buildings have retained more meaning and are more socially
valuable than the efficient buildings Loos proposed and the
box-facades Venturi endorsed. In 2012, the exurb can no lon-
ger be understood as the space to which urban society will
migrate, but the catastrophic side effect of speculation in false
concepts of refuge, with the largest increase in poverty and
lowest resource base of any form of community in the U.S. Who
will weep when the last Wal-Mart is torn down, when the last
Starbucks closes?

Like many indigenous peoples, the Okanagans of British
Columbia understood this problem in both "shared skin" and
super-positional terms: "Unless place can be relearned, all

other life forms will face displacement and then ruin. Without this self and this bond, we are not human." Participation in a shared aesthetic and material language is what defines a civilization, a culture, a home. Which is precisely what Loos, in his demonization of Papuan tattoos, missed. In the right context, at the right party, a tattoo is more useful and efficient technology than anything else. In the right context, sharing is the most powerful idea of all.

Notes

1. "Just what is it that makes today's homes so different, so appealing?," by Richard Hamilton, was created in 1956 for the catalogue of the exhibition "This Is Tomorrow."
2. "The Death or Decline of Art," G. Vattimo (1985).
3. M.H. Anderson, J.R. Ensher, M.R. Matthews, C.E. Wieman, and E.A. Cornell, "Observation of Bose-Einstein Condensation in a Dilute Atomic Vapor," 1995, Science 269 (5221): 198–20.
4. "Information heat engine: converting information to energy by feedback control," Shoichi Toyabe, Takahiro Sagawa, Masahito Ueda, Eiro Muneyuki, Masaki Sano Nature Physics (2010-09-29).
5. G. Bianconi and A-L.Barabási (2001), "Bose Einstein Condensation in Complex Networks," Physical Review 86 (24): 5632- 5635.

Adjaye Associates

Moscow School of Management SKOLKOVO

Sclera

Moscow School of Management SKOLKOVO

Moscow / Russia / 2010

This teaching and research institution was founded in 2005 to educate a new type of executive capable of leading Russian business through the 21st century. The founders felt that a campus-style development would best represent their aspirations, and acquired an open site in an area scheduled to become an advanced technology park, just beyond Moscow's outer motorway ring. Situated in the wooded valley of the Setun River, the landscape has the idyllic qualities associated with a traditional campus, but the severe demands of a six-month winter were a barrier to pursuing an arrangement of that kind.

The cross-section of Adjaye's entry to the architectural competition, held in 2006, was developed from the unrealized *Wolkenbügel* (or Cloudprops) project for Moscow, designed in 1925 by the Suprematist architect El Lissitzky. In place of the offices in the Lissitzky project, the teaching spaces were located in a horizontal plate supported on widely spaced legs, with the site continuing through the open space below. Although the founders were taken with the boldness of this approach, it was agreed that the unprotected space between the legs could be problematic in the winter. In responding to these concerns, Adjaye was inspired by the volumetric compositions explored by Lissitzky in his *Proun* series of lithographs and paintings completed between 1919 and 1924. According to Lissitzky, Prouns represented "an interchange station between painting and architecture." Many of them include a circle or part-circle, suggesting a gathering space that connects with its surroundings, as well as cubic and linear elements that radiate outwards in a free composition.

In the completed project, the teaching departments, a conference centre, restaurants, and other social spaces are housed in the 150-meter-wide Disc. This hovers above the site just high enough to protect the arrival zone and service area beneath it from the winter weather. The group of buildings that stand above the Disc give the development its variable profile when seen from different directions. Standing close to the edge of the site, the gold colored Wellbeing Center, and the administration tower, anchor the Disc to the sloping ground and look back to the center of Moscow. In the other direction, the blue tinged residential buildings are gently splayed to provide views of the Setun River.

Materials
Pre-cast concrete / Concrete / Mirrored and colored steel /
Clear, colored, and sandblasted glass / Aluminum

Total area 42,891 m^2

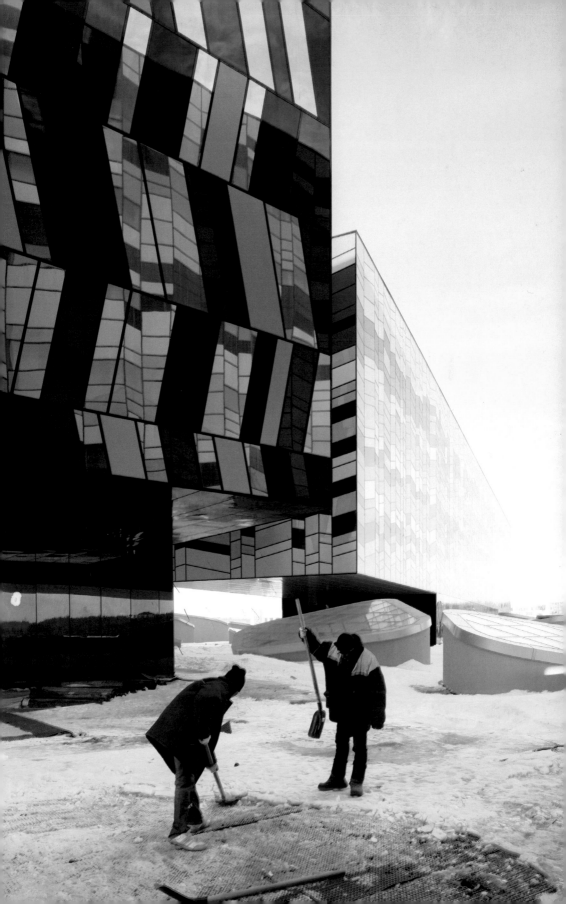

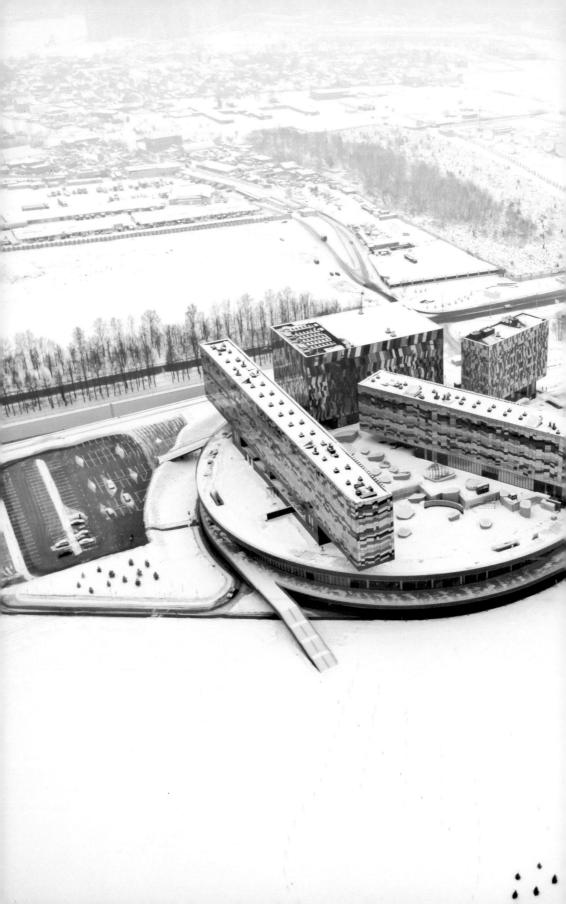

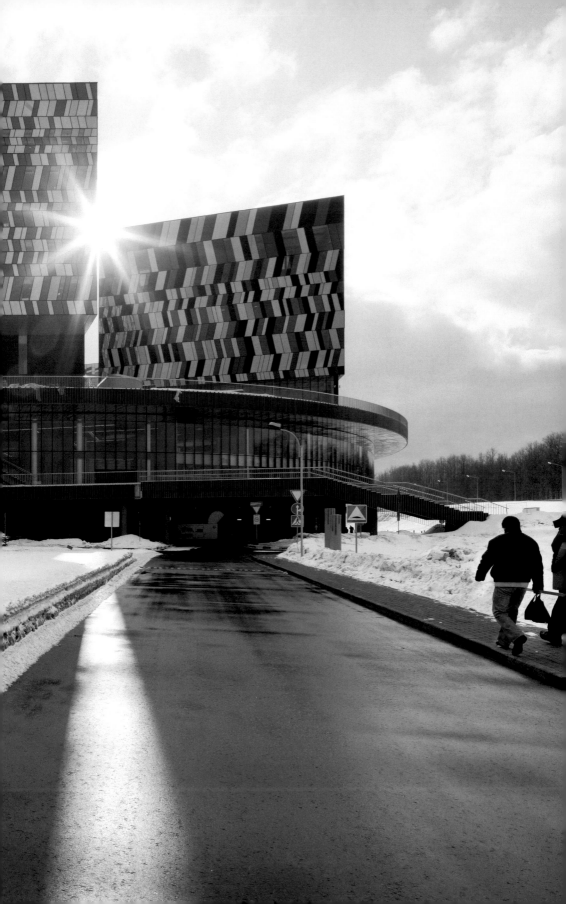

Sclera

London / U.K. / 2008

This pavilion was conceived as a contribution to Size and Matter, a month-long design festival. Standing within sight of the London Eye, a giant wheel constructed in 2000, Sclera was inspired by the human eye, the receptive organ that is the basis for visual perception. An exploration of form and space, Sclera also celebrated the structural potential and visual properties of a material that had only recently become available for external use due to advances in treatments.

Located in a small square within the Southbank arts complex, Sclera was open to the public at all times of the day and night. The closely packed frames of Tulipwood incorporated both floor and roof elements, and formed an oval-shaped building in plan. With its floor raised above the surrounding pavement, its interior was accessible by a circular threshold space at one end of the oval. The main circular space was also positioned on the long axis, with side walls that were, in turn, partially and more completely open. These openings provided intriguing glimpses of the interior from ground level, and from within, due to the elevated floor, they provided privileged views of the surrounding context. The curve of the suspended ceiling in the main space, which could also be seen through the larger opening, suggested the visual qualities of the eye itself.

Materials
American tulipwood

Total area: 78 m^2

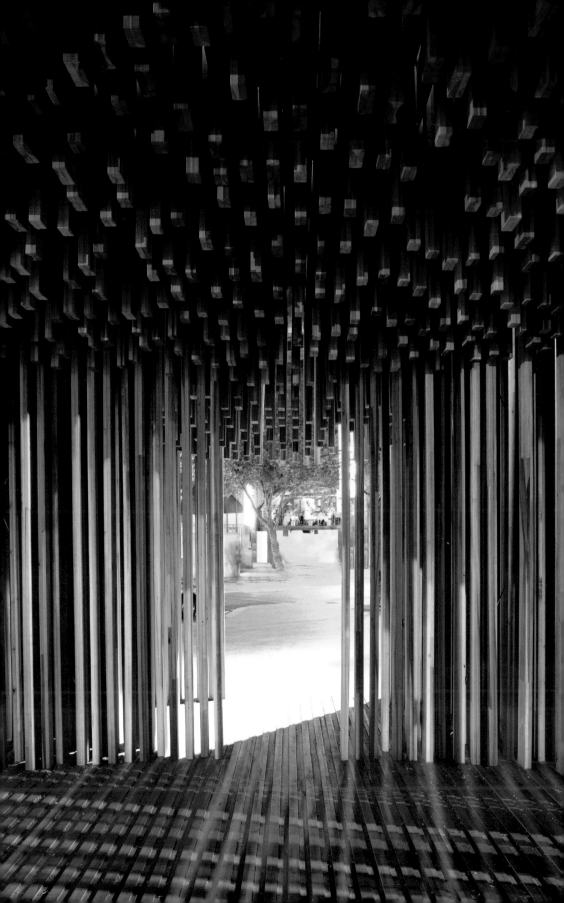

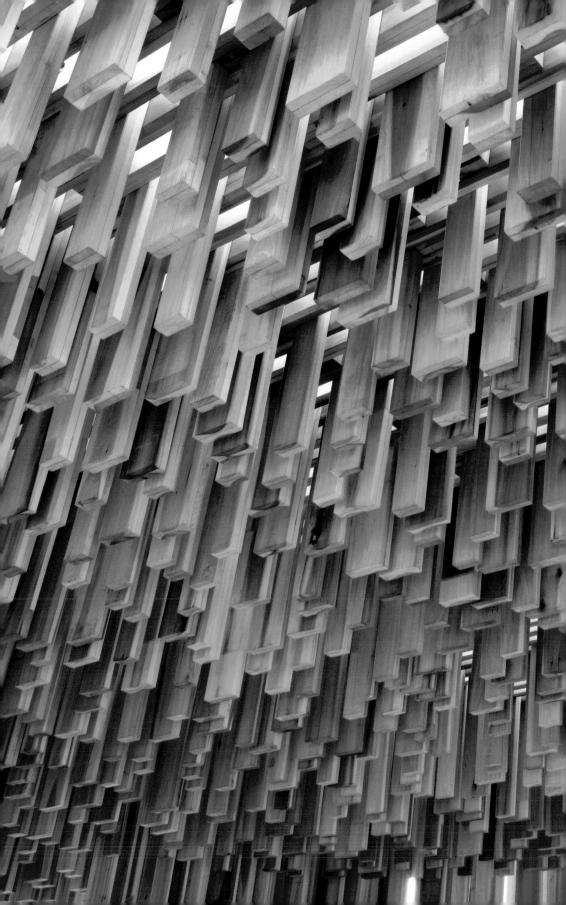

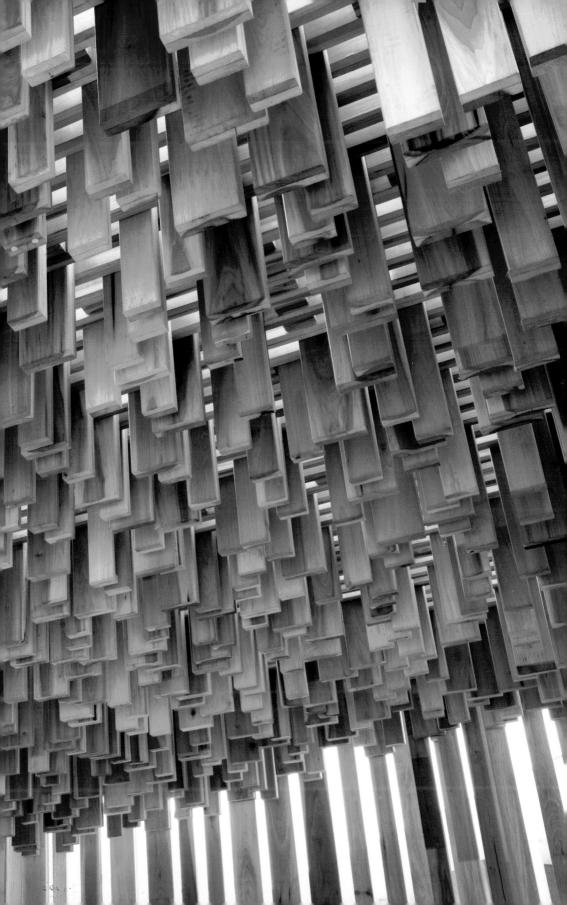

Co-authoring atmospheres

I've always been inspired by
architecture in the sense that it
is the ultimate form of immersive,
constructed experience.

– Teresita Fernández

Not-obvious

Teresita Fernández, David Adjaye, Marc McQuade

Teresita Fernández We started with this idea of non-standard. It's an interesting place to start, because everything came from that. As I was walking over here today I thought it isn't about non-standard, it's really about not-obvious, which is very different.

Non-standard implies that there's an alternative—a sort of catch-all, magical alternative, which is really clichéd. The idea of thinking outside of the box is a cliché. In fact, there is not an alternative. Sometimes not-obvious is just a tiny step away from really obvious or really dumb or really cliché, so I think it's more about degrees than about this idea that something's not standard or that there's this cure-all thing to find.

As the students got more and more into refining, they got less and less obvious about coming up with solutions that somehow seemed too non-standard.

David Adjaye "Standard" is very much playing with the architectural idea of standardized systems. But at the same time, you're right. The intent was not to make something spectacular or different just for the sake of being different.

TF Or not-standard.

Marc McQuade The tension between non-standard and not-obvious surfaced at the outset of the studio. Many students began with a strategy of being radical—that in order to achieve a project that is non-standard they had to throw out the standards they knew. But it's precisely

through a subtle tweaking of standards that you can begin to approach something not-obvious.

DA Right. It was always about how students can start to make their own language. Making language isn't just about screaming. It's about starting to take steps and take ownership of things that seem like ordinary things but that actually, when you take ownership of them, become very powerful. How do you define the space between non-standard and not-obvious? And why is that good now?

> **TF** It's about subtlety, and we ourselves in our own practices sometimes miss the subtlety, so it's this constant exercise. Language is a really good word, because as we try to find that alternative language, we find that we actually don't know that language. We understand it in a kind of emotive, instinctive way, but we don't understand it in the way that dovetails with the language of everybody else.
>
> So, really, that's what my studio is about. It's about, how does this language that I trust inherently get turned into something? For me, that transformation is where the art is. How does that get transformed, not into not a language that people understand, but just so they understand the whole in some way? How does it become a kind of container that holds it together without "telling myself a story"?
>
> I think of the whole "art speak" thing. In my education you had the art crit, and the art crit is a gentler version of the architecture crit where you're basically up there trying to defend what you're doing, but the language of how you defend it is so obnoxious in all of these forums. It's so standard, quite frankly.
>
> It's so standard, but it becomes a real crutch, because **students start to think that if you tell a good story, you have a good piece or you have a good building, and it's exactly the opposite.** It's precisely when you don't understand the

100

story but you know it's there that you're completely moved by it. And if you're not moved by it, nobody else is going to be moved by it.

DA That's such a difficult thing for architects. Architects are permanently being told to be in control of their narrative and to be clear about their narrative.

TF Well, artists are, too, to a certain extent. Talking about theory is not so interesting for me, because while I can do that, it doesn't make for very interesting art. If I ask myself those questions in the studio, I make art that's really well explained or that looks good in an essay form or as a description but doesn't really move you while you're standing in front of it.

DA The crux of the dilemma of architectural production right there! Architecture is full of fantastic theories. You can read all the books and at the end you should theoretically be able to make great architecture. But therein lies the problem, because even after all the input, there is no output.

TF It's not particular to architecture. It happens in art all the time, so people will see your work, and they'll say, "Oh, it's so ephemeral," or, "Oh, it's so this," or, "Oh, I feel this way when I'm looking at it," but they have a hard time when they feel those things thinking of the work as conceptual. They only think of it as conceptual if I give them the background.

DA Your work is highly conceptual.

TF Yeah, it's a different kind of conceptual. In fact, the conceptual part is not the hardest part to figure out.

DA We train architects to be very cognitive, and what's great about what you're saying, Teresita, is for an architect to dive into the non-cognitive side of their mind, the things that actually might be the real stimulus of their creativity.

That segues into this question of how does one teach design or art, apart from screaming at them and saying, "That's awful. Let's start again."

> **TF** It's like teaching somebody how to see. When you learn to draw, everybody worries about the pencil in their hand, and they don't realize that drawing is really about looking, so the more they're looking at the drawing, the less they're seeing. I think it's virtually impossible to teach, but you can absorb it.

DA Exactly. I don't think it will ever be objective—what A you get out of B—but I think it's about providing the right framework. We're trying to craft that system.

Context is everything. The way I talk about things all the time is about creating the context that nurtures and stimulates the potential for thinking like this. The real architectural moment in the studio is set by your presence and your energy and direction of thinking. The primary move was having you present in the context of an architectural education. It was important to have a practicing artist who is absolutely on an equal footing, and not in some sort of supporting role to the direction of making.

> **TF** The big difference was this idea that you don't get a brief, that life is not a series of briefs.
>
> When I am in my studio every day, it's a blank slate, and I have to write my own brief. My own brief happens when I wake up in the morning. It happens when I'm dreaming. It happens all the time, and so there is this kind of mental notating that's how I create my own brief.
>
> If anything, I felt like what I could offer to the students was this notion of going back to the brief and realizing that the brief really isn't that important, certainly not at this stage in their careers. But how do you make something without the

brief or independent of the brief? You need to have a level of trust in yourself. That confidence happens, I think, after a long time, but it's crucial to being someone who continues to make ideas.

DA What you're saying is really critical, because what you're talking about is a sort of lifelong inquiry. The idea that there is no checking in and checking out, that making is a kind of continual process that is always going on.

The idea of facing a brief is just a tipping point of a kind of giant iceberg that's your critical thinking that's already going on, and it's a way of making you focus for a moment. This idea that it's a kind of big body that's actually there, that's not actually necessarily about a cognitive-specific thing, but that the brief allows you a moment to wander and to daydream into something.

> MM Not having a studio brief took people away from the standard architecture studio practice of problem-solving. Many students were challenged early on not having a problem to solve. A lot of the success of the studio in my mind was this non-standard approach.

DA I think there is a crisis in architecture, which is that there is nothing to solve. The city is built. So the idea of making is a completely different thing.

We as architects are always still playing that game of the tabula rasa, of making the city or doing something, as though there's something to do. We don't even need to be here anymore, in real terms.

> TF There's also this kind of ridiculous notion that we all carry around that things are obsolete, whether it's a brief or the city, or a gallery space, or an idea, for that matter. I think that as we watched the students struggle with not having a problem to solve, and having to invent one, I found

it so interesting to see that they had a really hard time with the fact that their ideas changed.

We figure out this thing, and we put work into it, and it's supposed to stay the same, and it doesn't. It changes. The first idea, the first instinct, the first solution—if we want to call it that—is changing as you change.

In terms of how you teach that, I think that it's a wonderful mirror to how it is that we're not the same every day, and we're not the same every month. It's not always convenient to be able to not just detect but actually embrace the idea that there is change in our work and in our own ideas.

It's the most absurd thing in the world to think that you reject change because it somehow screws up your idea, and yet at every hump of getting to the next step of the more sophisticated design, what the students really had to do was to let go of everything that they had kind of thought they had figured out. We say "they," which is really presumptuous. I think we're doing it all the time as well. You had to do it, too.

In fact, there was one day toward the middle of the semester when I remember one of the guest critics said something like, "Listen, at this point, just stick with it. Just stick with it." It was the single most problematic moment for me, and I was like, "No, throw it out. How can you keep working on something that you don't believe in? You throw it out, and it's worth throwing out months of work if you can in one minute get to the next step."

DA I think this is the kind of entropic thinking that architects have been trained to make.

TF It's very hard to work on something that you don't believe in, but we can convince ourselves that we believe in something very quickly.

104

DA I thought something that was also very good about the way in which the studio worked was that almost every single student had an idea that was still so ephemeral at the beginning, but it was like we were acknowledging something that is so ephemeral and non-specific in terms of an architectural process that they were all spinning—but they were happy that we were happy. It was kind of this very nice moment. I remember thinking, "Wow, there's a way to start. You start with a kind of premise or a thinking."

 TF Exactly, a gut feeling.

DA A gut feeling, a thought, and that was seen as an absolutely strong way to start.

I'm curious to have your thoughts about the modes of representation that students used and your reflection on that. Was it annoying? Was it obvious?

 TF I thought that they were all much more sensitive at the end and that somehow the projects that worked best were the ones that had a kind of structural integrity but weren't actually solid.

DA Not so complete?

 TF No, just not so solid, not so much like buildings that looked like buildings; because one of the interesting things was that it didn't have to be a building.

 I mean, what's a building? Some of them really went with it and liked the idea that they were allowed to make a building that wasn't a building or that didn't look like a building.

DA There was something for me overall in the studio that was about a certain kind of super-sensitivity, a sort of delicateness. Even when they were being brutal in the sense of architectural brutality, I found a certain lightness and romance in that,

which was really interesting. I was actually quite amazed how that happened. It sort of just appeared.

TF Well, that was the absorption, because we kept celebrating and encouraging that; I think that they all just—

DA Soaked it in.

TF —became a little bit more poetic. **In fact, it's very hard to be allowed to be poetic.** Even in the art world you kind of have to prove it, and then you can be poetic, or somehow it's always this afterthought. In this case, because nothing was built, I think it really had a lot to do with visual presentation.

The students went, for example, from renderings that just look like interiors of whatever—fill in the blank—to these beautiful little vignettes that transported you to understanding what this space would feel like, maybe not what it would look like so much as what it would feel like.

I think it was a real leap when some of them realized that you had to prove the way it would feel, not the way it would look. In fact, some of the more abstract projects were the ones that were totally unresolved in terms of how to be built, but they were easy to fix that way and very much inspiring.

DA I like the idea of that old word, which is a bit taboo. The "poetics" of something.

TF I remember at some point one of the women in the class used the expression "anti-iPod," and we were all laughing, because it was such a generational kind of comment. They were all of a sudden thinking about things that we think of as very romantic, that have to do with sense and sensuality and the poetic and all this stuff that we read in school that's a little cheesy and romanticized. I think the acknowledgement of the sensorial for them was pretty radical and for a lot of

students it was this idea that you don't actually live with a headset on.

What's interesting about it is that we know that language, but we were missing something. We were perceiving from the perspective of our generation and education, but amongst them it meant something completely different in ways that I don't know that we even understood.

DA One of the thrills at the end was realizing how something as age-old as understanding that you're a sensory creature with other sensory creatures and making something for that universe completely translates differently for every generation.

TF Exactly.

DA It becomes a new thing again. They see relationships in the world differently and have different contexts to frame that. So something as simple as the Gowanus Canal, which you think is an obvious thing to everyone, becomes completely new.

TF It wasn't like I knew it, and they didn't. They just knew it differently.

DA I was struck by the incredible ephemerality and daring of some of the projects. Some students sought to see the city as a kind of terra firma and prepared new layers on top of that. There seemed to be this double game going on—above sky and below ground—which is straight out of the narrative of fantasy and science fiction. It's like, how do you make your world? Either you go under, or you're above, and then there's this sort of insertion of strange new objects into the context to radically reprogram it.

TF There was a pattern in a lot of the designs of the in-between spaces. I actually think those are the ones that were cool, but sometimes there was also nothing. Literally, smoke that was filling in space.

MM Drawing tied a lot of the projects together, which is also an such an important element in both of your practices. So many students really thought through their project by drawing. Even Miku Dixit, whose process was much more digitally scripted, in my mind had invented a kind of drawing technique in the same way that some of your graphite work does, Teresita. Although not a conventional drawing technique it's as much related to drawing as sculpture.

TF Right, it's very much drawing as thinking.

DA I think that's a really amazing aspect of your work. That from the same structure, but with a different set of ingredients, this incredible range of work has emerged. There's always this alchemy that I've been completely gripped by, where you have this ability to make matter into something magical. It's not magic in the sense of spells! It's more being able to take something ordinary and transfigure it into something that actually makes me think more than what it is.

It's about you and what you've done through your art practice, but I think it's also a really great lesson in understanding how to deal with matter today. Your inspiration to the studio was your incredible power to transfigure the physical world.

TF Right, that's what I'm interested in and what all the work is about, transforming—and the word I use is alchemy as well. What I'm known for in a way is taking ordinary materials and changing them, but it's really never about the material. My work is always about the thing that you project on the material.

DA But I always find that you don't change the material either. You reframe the material instead.

TF That's what alchemy is about. It's about layering other things onto it. There's actually no matter to it at all. It's about

what's projected onto it, and that is intellectually mental. But it's also emotional, which is an aspect that no one ever wants to talk about, because it's the most difficult thing to talk about, but it is precisely those articulated things that change the matter.

DA Beautiful. I think that in the built environment, that level of conversation makes it start happening. I think we've been very good at scripting structure, efficiency, regulations, air rights, laws. We just have no idea about emotion, about sensitivity, that sort of reaction to things.

TF It's not particular to architecture. It happens in art all the time. People are used to talking about the product. They're used to talking about what's in front of them, whether it's a painting or a sculpture or graphite.

It's graphite. It's about graphite. In fact, it's not about graphite, but we're always programmed to talk about what's in front of us. It's definitely not particular to architecture.

MM One danger is you end up describing the poetics of the piece. Poetics are not meant to be described. How do you describe this non-material aspect of your work?

TF I don't. I make art!

It's a little bit about not talking about it. The minute you talk about it, it's not that interesting, because it's like talking about an experience. You can either look at it or you can take a picture of it, but you can't do both. You can experience it or you can talk about it, but you can't do both. One language completely destroys the other.

MM Would you teach architecture again?

TF It made me aware of how much more old-fashioned teaching architecture is than art. It's way behind and very formal.

109

DA That's very true.

TF It's very formal and hierarchical. The way the crits were set up was about a thumbs-up or thumbs-down, like a jury. It's different than an art crit when I was in school fifteen years ago, which would be more of an exchange. Not that they couldn't be tough sometimes, but it was really more about engaging in exchange and holding your own within an exchange, rather than presenting and being juried, good or bad. That mentality seems really dangerous.

DA It is. There's a whole patrimonial culture that's been perpetuated by a certain generation, and we've taken it as the norm now, and there's no reason for it. There was a movement in the eighties toward this aggressive, top-down, have-you-been-sanctioned mentality, and we're still in the residue of that as a way of teaching. It's just something that needs to be stopped.

MM That culture still persists. I had some students come to me after one review who commented that there wasn't enough fighting.

DA Cultivating commotion is such an old idea of what generates discourse.

TF It assumes that you're smarter than the students, which isn't always true. Anyone who teaches knows that half of the reason for teaching is because you're energized with new ideas.

One thing that I thought was super important and, as a woman, watching, for example, was that some of the women in the class were at a disadvantage because of the structure that they've been taught in. I couldn't have stressed to them any more that you cannot be emotional when you present your work. It's teaching someone how to be sensitive but not dramatic. It's possible to be emotional and sensitive in the perception of your work, and then completely composed.

It wasn't just gender. In general, there were some people who were more vulnerable at the exercise of presenting, and they all have to work at communicating the visuals. They also had to really figure out how to present in a way that wasn't emotional or dramatic or any other way than composed. It's a super-simple lesson.

Artists don't usually have to present their work that way; I think it's something particular to architecture, which most every architect has to do. It seems like a really crucial thing to teach how a sensitivity can transform into a confidence.

Teresita Fernández

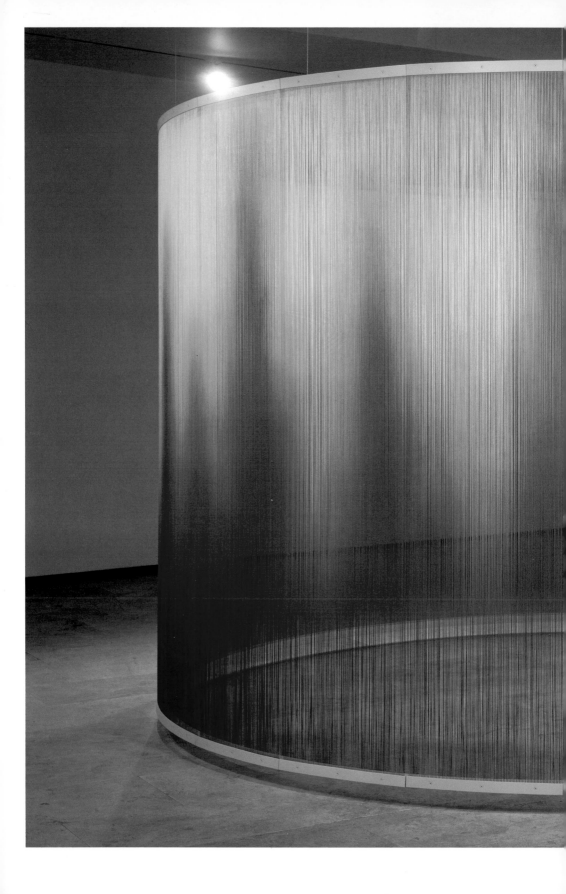

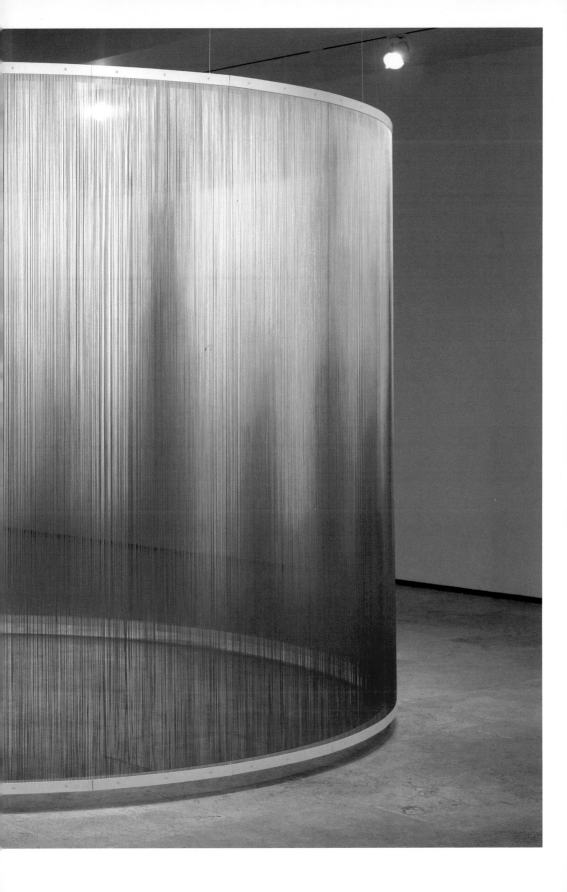

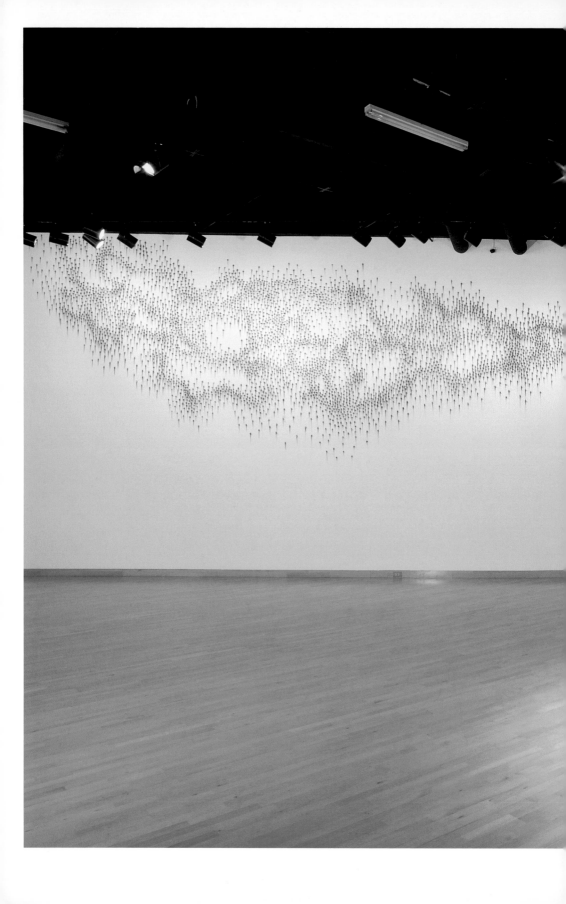

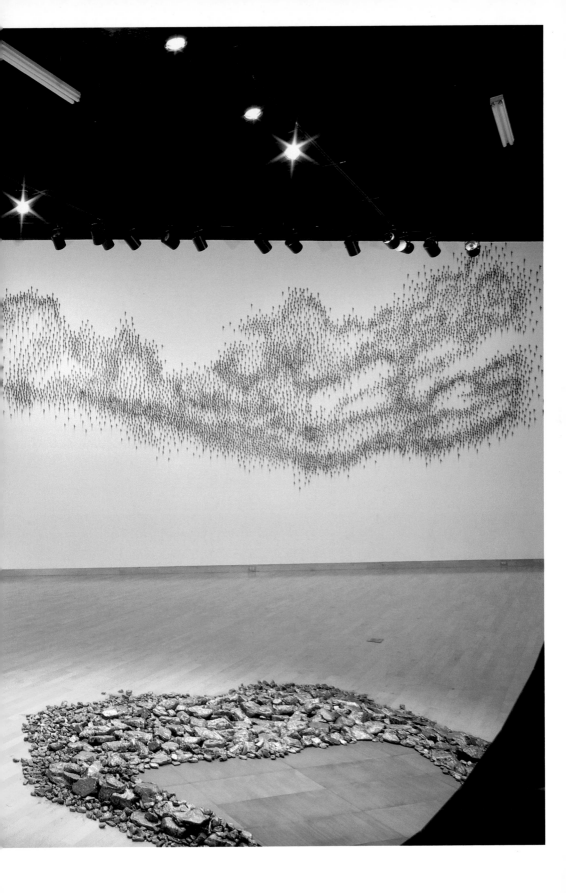

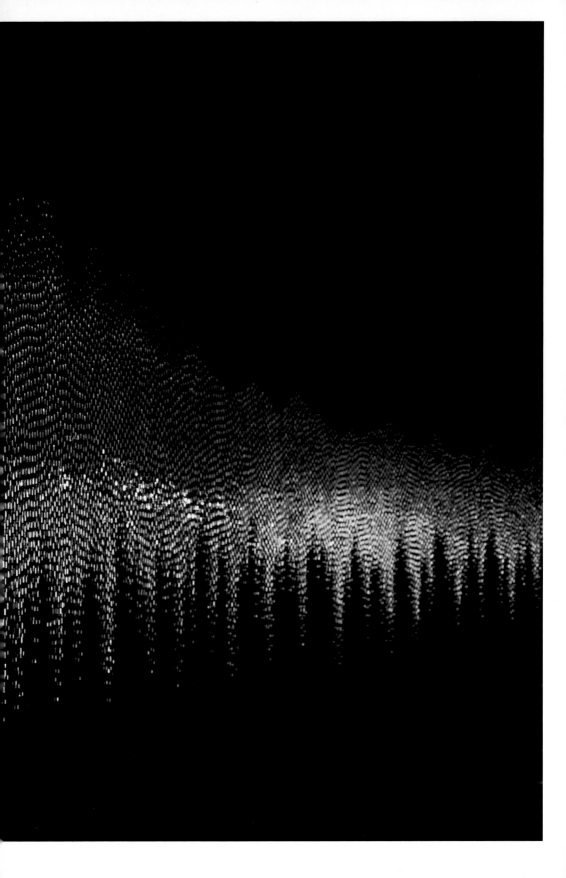

Tropical Scholarship

Dave Hickey

In our laziness, we assume that the art created in a particular cultural moment is an expression of that particular moment. This is almost never the case. In my experience, the art of a particular time and place is more likely to be a compensatory gesture—an effort to replace those pleasures and comforts that circumstance and technology are presently taking away. As a result, I find it most rewarding to think of persuasive new artworks as wild cards that help us complete the hand that culture is presently dealing us. I think of Abstract Expressionism compensating for the post-traumatic blandness of postwar America. I think of Pop and Minimalist art as compensation for the elitist Marxist and Freudian critical culture that abstract expressionism created in its wake. I think of Post-Minimalism and Conceptual art as compensating for the spectacular mindlessness of Pop and Minimalism in their grandiose cynosure.

From this perspective, new art may be said to have fulfilled this particular social function in the moment that it becomes culture, when it enters the realm of academic typing, history and sociology. At this point, art has become less interesting to those of us who are interested in new art as a prescient act of compensation that allows us to conjure up the ghost of Christmas Yet To Come —the presently invisible cultural deficit for which this new art is standing in as a wild card. This is why, even though I would never refer to a cosmopolitan artist like Teresita Fernández as a "Miami based artist" or even a "Cuban-American artist," I do think of her as a "tropical artist" who deals with issues that, in my own critical vocabulary, are peculiar to "Tropical America"—a cultural configuration that is only gradually gaining and expressing its new and accumulating relevance.

To begin with, Fernández has inherited a Latin-American history of art that is distinguished by its direct traverse from the Baroque to the modern untouched by the rationalist Enlightenment. This narrative, that jumps from the Baroque to the Surreal to the abstract, is less radical than it might seem, of course, since one narrative bloodline works as well as any other in a democracy, and, over the years, this elided history has created a modernist idiom of Latinized color and geometry that Northern critics (when they refer to it at all) call "sexy modernism"—a modernism that does not come freeze-dried by Enlightenment rage. These critics, of course, have not yet decided if "sexy modernism" is a good thing or a bad one, but I vote for good, mostly because it provides a persuasive alternate story for the coming of age that American painting underwent after World War II; it suggests a history that moves directly from the Mediterranean Baroque, through the actual and indigenous surreality of Latin culture, through the visual politics of revolutionary Latin-American modernism to the triumph of New York School painting. From Titian to Miró to Siqueiros to Pollock to the new world of postwar art, in other words.

This is worth mentioning here because Teresita Fernández's work feels comfortable in this flow, as does the work of other tropical Americans like Jorge Pardo, Jim Isermann, Ken Price, and Robert Irwin. All these artists engage in an odd romance between chaos and design. They opt for an impersonal rejection of Romantic auteurism. The work of these artists is interesting as art, of course, but it is also interesting as a compensatory cultural proposition that seems to be on the winning side. This because behaviors, phenomena, and objects that, in the North, seem to invite or demand deconstruction, are already in the process of deconstructing themselves in the mutable South.

In my view, then, the world that Teresita Fernández evokes matters more every day because Fernández's affection for tropical culture softens the hard distinctions between one thing and another, between one place and another, and one

130

identity and another that pass as hard currency in the intellectual casinos of the North. In the tropics all is flux—dirt turns to water, water turns to air, and air back to water and dirt. In this world, culture is the grid and the plane. All the rest is fluid nature, which, since most of it has been imported, qualifies as culture too, or the fantasy of it. The visual irony of Fernández's *Ink Mirror* is that both the vertical, black, rectangular slab and the dune of white sand from which it arises are as natural as they are cultural—and probably something beyond both since they evoke an imported, imaginary landscape that humans built and in which real humans dwell.

Living in this world, in the fantastic temperate cocoon of Tropical America means that one's mind is not fully occupied with keeping one's body alive, so the mind and the body blur at the edges, and since your body is at home in the air around it, the self and the other blur at the edges too. The "class-language" of clothing is suppressed, as is clothing itself. The echoes of one's self move outward in arcs of physical resonance. As do the physical attributes of one's world. The bougainvillea in your yard is yours first, an extension of your body's centrality, and only secondarily, God's nature. One lives in a full world in which one is occasionally punished but never inconvenienced by the climate—a society in which fine distinctions are hard to come by.

So Fernández works at the edge of entropy but never beyond it. Her work exists in the domain of the translucent, the reflective, and the blur; she embraces the scatter, the splatter, the explosion and the splash, the grid and the plane, and only as much physical matter as it takes to achieve the curve, the shine, the dazzle, and the lineaments of culture. Her objects occupy the realm of surfaces and not the realm of objects, because the easy Northern distinctions between space and volume, between one's interiority" and one's exteriority, and between appearance and reality, dissolve in the South. Manners and morals become indistinct. The idea of "identity" has no practical meaning, and the qualified virtues of artistic chaos and

abjection that feel so necessary in the over-organized North approximate the conditions of tropical life so closely as to become trivial.

So this is my question. What is the wild card in the hand that Tropical America deals us. What do the tropics need? Or, what does an artist in this environment see that needs to be done? My suggestion is that the tropics are always in need of a good redesign, not a Northern redesign that extends the bland encroachment of repressive geometry and not a Disney World reproduction that only reminds us of it's unauthentic absence of thorns and insects, but a tropical redesign that speaks its own language, that provides a stable armature at the intersection of nature and culture for its mutable profligacy. Morris Lapidus identified this intersection as the curve, the shape nature and culture share, where mathematics, calculus, and physics meet the harbor, the bay, the wave, the dune, and the bend of the river.

Lapidus began his Fontainebleau Hotel on Collins Avenue in Miami Beach with the curve, because, as he told me once in an interview, curves signify leisure, because a curve is the longest, most beautiful distance between two points and we are tropical human beings who are not in a hurry. Also, curves are sexy because human beings are curved and the curvier the sexier. Curves also stand for change because curves are how we measure change and express it. Curves signify flexibility and adaptability to nature, because nature is not rectangular. Curves also stand for self-sufficiency and independence, because, as Richard Serra so aptly demonstrates, curved walls can stand free and straight walls cannot. "A lot of good things about a curve," Lapidus said, "and about ovals and circles and biomorphic shapes because they have no normative 'size' relative to any enclosure they might adorn."

For these and other reasons, I'm sure, Teresita Fernández organizes her work around the curve. She balances her work on this precipitous fulcrum. She deploys fields of stones and

glass in rectangles and explodes them into biomorphic shapes without destroying the inference of their original shape so the exploding stones seem to tug back toward that configuration. She exploits the elevation map (with its stacked plates of variable configurations) as the classic signification of fractal nature's intersection with cultural geometry. Fernández translates the landscape and flora of the tropics into cultural objects by translating them into horizontal and vertical plates that trace out the irregular planes of their configurations in fractal detail. Thus, in Fernández's language, *Precipice* becomes a crooked mesa of gray stairs; the *Dune* is a shaved, dazzled stack of concave planes—like a choir riser for tiny people. Her *Waterfall* is a slow free-floating curve of luminous blues that flows down from the wall to the floor, marked with horizontal lines that locate the planes of the space through which the object curves. Instances of willow, wisteria, acacia, falling water, and tidal residue present themselves in relief, in reflective precision, as intricately cut stacks of stainless steel planes through which the light falls and from which it reflects.

The formal function of Fernández's planar objects, it should be noted, reverses the function of this practice in architecture. In architecture, the stacked irregular planes of the articulated elevation maps are intended to extend the contour of the landscape. In Fernández's sculpture, the vertical and horizontal plates accommodate her fractal objects with the rectangular enclosures in which they are exhibited—a minimalist device in baroque circumstances. All of these works, in fact, may be taken as confirmations of Bernini's contention that there is nothing so ephemeral or protean that a master sculpture cannot freeze it forever. Fernández's translucent thread pillar of fire, also speaks to this aspiration and suggest a group show of works that share this ephemeral aspiration by Peter Alexander, Robert Irwin, and Jesús Rafael Soto.

The interesting point for me is that Teresita Fernández and her colleagues in this delicate endeavor (Pardo, Isermann, Alexander, Price, Irwin, etc.) are children of Tropical America.

They have a touchstone in those southern corners of the conti-
nent that in their climate, culture, orientation, and iconography
are not properly America at all, but not properly anywhere
else. In the years of their innocence, these corners of the conti-
nent were literally nothing and nowhere at all—just big sky, big
clouds, saltwater, sand, dirt, and that full, luminous haze,
created by light bouncing off the water that makes the atmo-
sphere a thing in itself, a palpable realm of blur and dazzle.
Nothing was quite itself. The sky, the sea, and the landscape
blurred together at their intersections. There were also weeds,
brush, palms, marshes, deserts, reptiles, assorted rodents,
and a scattering of scantily-clad human beings. Nothing too
organized, and even today, in its penultimate cultural maturity,
after human beings have added plants, streets, flowers and
architecture, Tropical America has not changed that much: As
societies, Los Angeles, Miami, New Orleans, and Houston as
well are still less proper American cities than swathes of equa-
torial wasteland divided into tribal neighborhoods.

In the years of its social lowering, theorists referred to the
realms of Tropical America as hyper-places, or surrealities.
Today they just shrug and say so what. They acknowledge
that these places may not constitute nature or culture by
American standards, but they are no less real. They admit that
our comfort , with the putative inauthenticity of these tropical
cosmopolitan tangles speaks to the death of Culture as a viable
idea and to the waning of Romantic Nature as an energizing
concept and not to the "decadence" of these societies—espe-
cially when one considers the fact that, when approached
from the South, Tropical America seems to be a perfectly
ordinary and comfortable place. What has changed is that
Tropical America, which was once regarded as a final refuge
from Protestant America and not as an extension of it, has
finally become a real place. More to the point, as mainstream
America has become more and more a place from which one
might seek refuge, this world has begun to look more and more
like a viable alternative to the dominant culture.

134

One simple principle supports this option: the joys of Tropical America with all faults can be made more livable with less effort than the conformity of Middle America may be made more joyful. Any urban designer will tell you that the messy, chaotic infestation of human beings that constitute the America's tropics may be tidied up more easily than the rigid culture of the heartland may be relaxed into a more 21st-century posture. This assumption lies at the heart of Eames, Schindler, Neutra, Lapidus, Gehry, and many others, it informs the architecture of California Modern and Miami Deco, although the difference between these architects and artists like Fernández, Pardo, Price, Irwin, and Isermann speak volumes.

One would imagine that architects and designers, whose works are bound by their function and interdependent, with the surrounding environment, would aspire to make a more generalized, less dissonant statement than artists with no such caveats who are creating singular objects. In fact, the reverse is true. All of these artists create handless and virtually impersonal objects that are routinely overwhelmed by the ego and theater of their designing and architecting colleagues. This because these artists, so often, degraded by their association with design, do, in fact, transcend design more profoundly than those who visibly reject it, because these artists are designing function and beyond, themselves, to some philosophical purpose. They are creating, for the first time in the West, some occidental approximation of scholar's rocks and Zen gardens, quiet sites and objects of contemplation that speak to a collectively imagined society. Each is a parable of sort, so if the work of Teresita Fernández seems too quiet for you, shut up and listen.

Adjaye Associates

Silverlight

Within Reach

T-B A21 Art Pavilion

Silverlight

London / U.K. / 2009

The concept for this new-build home, located on a narrow strip of land between a busy road and the Grand Union canal in West London, developed as a careful response to the urban context. The main volume continues the parapet line of the Victorian pub to the east—a listed building—and the horizontal lines of the cladding system relate to the window heights of the older building at the edge of the site. Due to a high level of traffic noise, the north façade has very few openings, but avoids being dark and gloomy thanks to the aluminum cladding, With the availability of light and views in the direction of the canal, the south façade features more windows and the vertical height is broken by a two-story extension whose triangular plan is determined by the angle between the road and canal. The height of the extension connects with the roofs of the neighboring workshop and buildings across the canal.

Inside, the section is organized as a series of parallel spaces that move from one condition to the other. Each floor is conceived in a manner that is consistent with its purpose and is largely independent of the arrangements above or below. Although the new floors are open to the south, the singularity of this arrangement is obscured by changes to the section of the façade: the mirrored slots overlooking the canal, the enclosed court on the first floor, and the colonnaded gallery on the second floor. From the archaeological character of the basement to the screened forecourt at ground level, the sense of enclosure in the guest and music rooms compared with the expansive privacy of the master bedroom, the loose formality of the living space, and the open vistas of the roof terrace, the house offers a wide range of locations for different activities and states of mind. In this context, the staircases are designed to promote choice and continuity within a range of scenarios.

Materials
Concrete / Stained concrete / Stained plaster / Crushed glass / Zebrano / Resin floor / Aerated concrete / Aluminum composite panels / Fabric lining / Bamboo / Insulated glass / Translucent double-glazed glass / Sand resin flooring / Recycled plastic panels / Polycarbonate / Colored MDF / Spray lacquered MDF

Total internal area: 406.5 m^2
Total external area (roof terraces): 90.5 m^2

Within Reach

Venice / Italy / 2003

This installation in the British Pavilion at the Venice Biennale in 2003 was based on a collaboration with the artist Chris Ofili. He wished to show his paintings in an environment that would enhance their atmosphere and break down the distinction between his imaginary world and the experience of the viewer. In their unadorned state, the neoclassical spaces of the pavilion would have stood in stark contrast to the scenes in his paintings.

To achieve this end, a kaleidoscopic vault, consisting of shards of glass in similar colors to Ofili's paintings, was suspended from an aluminum framework standing between the new enclosure and the shell of the old building. Arranged in a loose spiral, the shards reduced the amount of natural light reaching the central space by about half; the light levels in some of the peripheral space were even lower. This was part of the strategy to unify the experience of the paintings and the space. Spatial arrangements at art fairs are often designed to allow for large numbers of people. The intention here was to create a setting in which people would value their own experience and perception. To this end, two separate entrances were provided to give a choice of route through the installation.

Materials
Aluminum tubing / Colored glass / Felt / Carpet

Total area 257 m^2

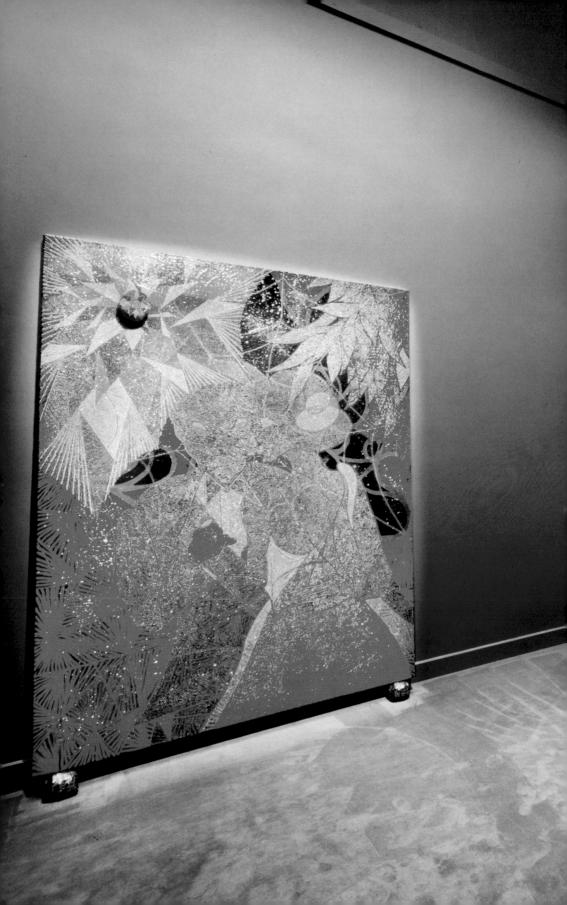

T-B A21 Art Pavilion

Collaboration with Olafur Elisasson
Venice / 2005 and Lopud / Croatia / 2007

This project was the result of a collaboration with the artist Olafur Eliasson and concerns the viewing requirements for one of his works. Your Black Horizon consists of a recording of the changing intensity of the sky during a single day, firstly in Venice and secondly on the island of Lopud. The recording is then projected continuously, moving through a complete cycle in 15 minutes, as a continuous narrow band that surrounds the viewer. Aside from the provision of a dark enclosure, it was important that the viewer should be able to enter the space enclosed by the projection without any disruption to the image.

In Venice, and on Lopud, the pavilion was located in beautiful settings to enhance the overall experience of the viewer and to heighten awareness of the differences involved in moving from one site to another. Employing timber for lightness and ease of reassembly, the organization of the pavil-ion sets up a series of increasingly dark spaces that gradually accustom the viewer to the blackness of the main space, where the floor is placed above ground level. This arrangement allows the viewer to enter beneath the line of the projection and then ascend to the main floor on a shallow ramp. The projection itself is located in a slot in each wall, and the spatial awareness of the viewer, once inside, is heightened as the light moves through different levels of intensity and color. Retracing one's steps, the eye gradually adjusts to the brightness of the exterior; in this way, the pavilion functions as a belvedere from which to view the landscape.

Materials
Heat treated timber / Orientated strand board / Corrugated
bituminous sheet

Total area 257 m²

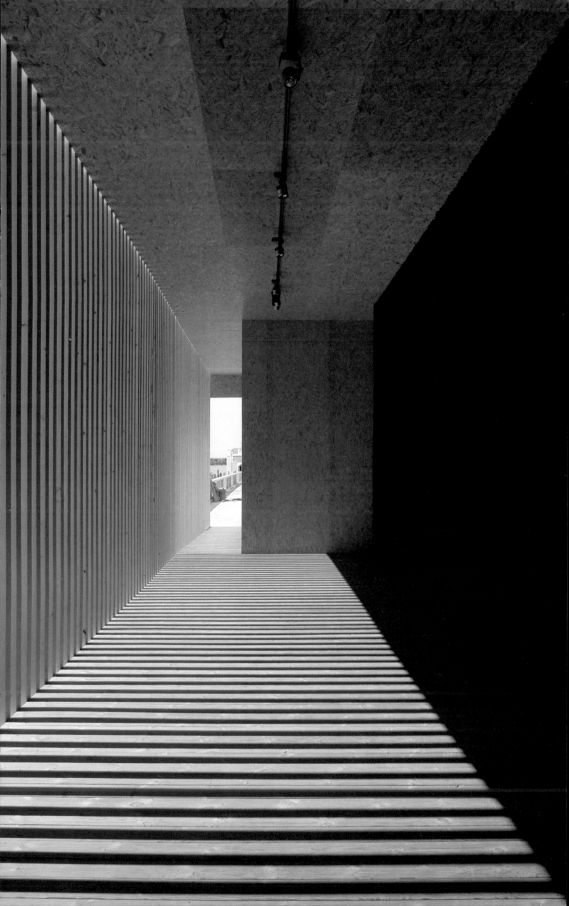

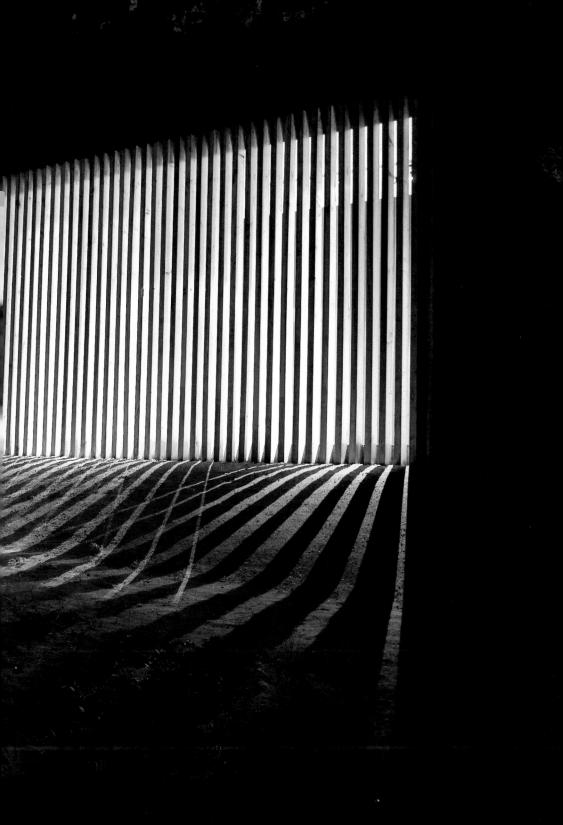

Re-authoring communities

For me, to optimize architecture is not the issue. It's really to use architecture.

– Jorge Pardo

Look at It Again

Jorge Pardo, David Adjaye, Marc McQuade

Marc McQuade Having studios in L.A. and Mérida, and being born in Cuba, could you tell us a little bit about Mérida and the impact of place in your work? How does your work translate and change from the different contexts and sites that you're working and exhibiting in?

David Adjaye Yes, why that place for you?

Jorge Pardo Everything's driven from L.A. Mexico's a little different because it became interesting to me as it became more of an intimate place and not necessarily just as a place for basic production. I just started to feel really comfortable there. I enjoyed not being in L.A. there, and as a result of that it was more like, "Oh, well, I'm interested, I like it here. I wonder what it would be like to spend more time here. How could you work here? What's available to you when you start to move?" And when you really move, it's not just a question of moving for another job, because I've done work all over the place. Maybe it has to do with the fact that it reminds me of being born in the Caribbean; maybe it's about the heat and the humidity. It's very close to the United States and it's radically different— radically, radically different. You could be in Africa. You could be in Southeast Asia. And it's right here.

It's right on the doorstep, and it's an interesting place to rethink yourself, to re-look at a lot of things that are put forth in many more stable platforms like Western Europe and the United States. How can things operate differently? That's still a question I'm very involved in trying to understand. What does it take for you to develop critical mass culturally in a place like that when it's driven from a practice that's not a sentimental relationship to that place?

I think places are specific at the end of the day. The only thing that I think about is the question of how I anchor myself in this place. To what degree? How do you actually function as somebody who's not from there? I'm an American immigrant. I wasn't born here, and that's always a big issue in general and always been an interesting problem, and it's always what drives all the issues that I think about. How do you form yourself in places that you don't have a naturalized relationship with? At the same time I'm very American.

My interest in Mérida emerged really organically. I designed this project for an exhibition that is a house that ended up being a photographic project, and then I got involved with the Hernandezes and something weirder happened, and now this studio with Princeton. Generally when I teach I usually bring whatever's happening in my studio to the students; I try to fold it into the pedagogical process. It's pretty straightforward.

> **DA** Your straightforward is not really everybody else's straightforward!
>
> I love the way that you bring language down and make big ideas completely accessible. What was incredible was that the students felt that they could talk and open up to you. You allowed them a space where they could parley with you on equal terms. That was a really fascinating trick, because I know a lot of people who don't do that.

JP One of the first things that I realized about teaching architects in a place like Princeton, an Ivy League school, is that it has a much more formal social protocol and etiquette in terms of the differences between teachers and students. Art schools aren't like that so much.

I come from a pedagogical background where the people I work with are people that are just around, and you interact with them. And also the California tradition is a different tradition. It's a much more informal tradition in general. The relaxed

Californian has been clichéd historically endlessly, but I think that it's true, you know, since our programs in California are fairly new. They're really from the '70s, and were very radical. They were trying to reinvent that whole dynamic, and that changed a lot of places. A lot of the pedagogical infrastructure has found its way into other parts of the world.

The students are your equals in some way. They don't have as much experience as you, they haven't seen as much, but it's your job to treat them as professionals right from the get-go. I like teaching and I like teaching in that format, because it wasn't a large number of students, and we got a fair amount of individual time with them, which is ideal.

> **DA** The unique thing about teaching at Princeton is the select number of students; you can actually give more, which is really critical.

JP There was also this interesting issue for me, which is that I was teaching and trying to understand the landscape at the same time. I always felt like an outsider, and for obvious reasons. I was trying to understand and measure where someone like my authority would register within the framework that you had set up. **I do practice kind of an odd form of architecture, but it's always under the rubric of exhibitions or projects where things become reflexive in ways that are slightly different than typical architecture. I purpose architecture in a slightly different way.**

> **DA** What has always been powerful for me is the way you manage to take architecture which can be very structural and take it into this post-structural thing where you can absorb it and use it to do other things. Usually architecture serves other people but never serves another intellectual agenda as an autonomous thing. You're the only character I know who has managed to do that, and that's what I find really inspiring about your practice. **You manage to re-conceptualize the radicality of architecture for whatever**

agenda you want it to be. You decouple it from its traditional realms.

JP One of my strategies is to always position myself so I'm in and out of architecture at the same time. The projects always come through exhibition purposes or a collector who's interested, or some kind of odd situation. I design my own sort of things to build with very specific reasons.

DA You talk about a comfort of not being an architectural expert, even though you are. But, in a way, by freeing yourself from the idea of having to be an expert, you seem to be able to manipulate the material in very surprising ways. I'm thinking of the smoking pavilion that you did on the lake in Münster, for example. I remember seeing that and being completely struck by the utter simplicity, but the profound relationship it made to context. The discourses at the time were so complex, and for somebody else to actually set up a scenario like that would have been so much rhetoric, but you somehow managed to excavate all that rhetoric and get more elemental, and it wasn't minimalism. It seemed to be much more reflexive, and able to engage a context and ideas about value, people, community. It did all these things with the usual elements, but with more force.

We also had the pleasure of having the students and ourselves spend time in your Mérida house and realizing how performative and social that house is. It was a perfect setting for the theater of public life, debate, discussion, and exchange of ideas. It fostered an intensity. It was all those things and I found it so rich. It's impossible to write program for that, but you somehow are able to do that. I've always been intrigued about how you manage to get more out of your work than what appears.

JP That's interesting. The work is not formulaic because my thought processes are too disorganized!

158

DA From the Hernandez project to that Münster pavilion I can definitely say your work is not formulaic. It's actually very site-specific.

Roberto Hernandez — at Tecoh Mexico

JP It's very site-specific. And what I try to do is take some less legitimate aspects of how you would approach a kind of site problematic, and then I let some of those things in. It's just not a traditional, formal kind of communication. Let's take Münster, for instance. I was thinking that what a sculpture needs is inhabitability—do you know what I mean? It's a question of how you charge a site for reflection, which is what this thing does—and it does it in a very structured way. It takes you from the land and puts you in the water. You walk out and start to see things and connect to the city. You can actually see the center of the city from the site. Basically you're allowed to access the axis, and then you're presented with problems when you're there. They are very simple problems, problems about how you see and what you do. And the cigarette machine is a kind of ridiculous thing to put inside, but at the same time it grates away at a much more traditional, bucolic finish.

DA Yeah, it's almost like making something perfect and then vandalizing it!

JP Yeah! Or maybe, "Look at it again."

DA Oh, "Look at it again," even better. That's a great title.

Let's talk about the Hernandez project, which is the most extensive thing I've seen you do. There was something profound about the way you both made the landscape and the thing that you inhabit as well. I don't even want to call it architecture. It's this thing that's between architecture and art. What was it like when you actually created the site and controlled the thing on the site that you were trying to do there?

JP It's more difficult because your job then is to devise a program, so the first thing I did of course was not have a program and really think of it in terms of a series of follies and events that happen in the landscape.

> **DA** What is it about the folly, which is a very historically loaded word?

JP Basically it's a British landscape trick that makes optic space in the garden. It's a focusing, framing device. And it's interesting because it has a very abstract purpose. **The folly is not a program of shelter; it's not a program of function; it's completely optical. It's one of the few things architecture has that butts up against a more optical tradition, which is something you can grab onto.**

It's the first time I really worked with a series of places within a site, and to me that seemed like a really simple and active device in a way.

> **DA** Something that I find very powerful about your work is that after you set up a scenario, it breaks down into smaller worlds that reframe the very things that it already sets up, and then reframes those back to you again. That is a very interesting technique and a contrast to the traditional approach where one would have something to react to and then set a series of frames. That's a really powerful tool, and one that I think is not fully understood in terms of how we make things, especially at the scale of architecture. We are obsessed with the autonomy of the process and the delivery of the form according to a brief, and not according to the kind of nature of the form one is making and what it's doing.

JP The Hernandezes were properly briefed that I didn't really know what the purpose of the building would be. It was a real luxury to be able to work like that for five years. And now we're at the end of the line and are trying to program this thing.

160

MM Has the growing scale of your work and studio changed your practice?

JP I don't really think about scale; I think more about the problems of scaling up.

When I started looking at buildings I had a friend who lived in a Schindler house and I started doing some research, and one of the things that I really like about his practice is that he never grew. And yet he was incredibly influential in Southern California.

DA Right, doing more does not mean you're going to be influential! We're loaded with the pressure of historical meanings of larger scale. What is the trajectory of large-scale projects? Where do we fit within that?

JP It's a matter of operating at a size where you can stay engaged, because at a certain point you're not able to touch everything. You guys know it better than anybody, as you're in the middle of scaling up now. It's like, how do you stay in it?

DA How you stay in it is critical.

JP That's the bottom line, really. **To scale up always involves a jump between what you see and what you would like to do.**

DA What you've just outlined are some really big ideas and I'd like to talk about them in relation to the studio. There was a way of understanding the site that came out in our studio with you that was not a perspectival, optical understanding of the site, but rather a geological sense of the site.

JP The program for the class was pretty open. It's almost like we were asking them to operate within a folly as well. And none of them really did that, but I think they came up with some really great solutions.

161

DA When I look at the work again I am completely struck that somehow the students managed to indirectly or directly tap into a certain kind of knowingness that was not a pro-grammatic knowingness. The studio also started to prefigure a way of drawing which was not convention. The invention of drawing. I think that that had become one of the tropes.

JP That's one of the under-layers. **When you teach artists, part of your job is to always help them make sense, which is kind of the opposite of this studio!**

DA Right; we try to have them not make sense! That's really funny, actually, because of course young student artists are obsessed with making things that contribute to an understanding.

JP Right; and then it's your job to map their work within a certain tradition so they have access to things that they can continue to pursue, or maybe even to help them understand what they're doing.

Involving myself in this class with you was really kind of an experiment to some degree, because it's new territory. When I go to art schools I'm kind of locked and loaded in a way. There's a language that artists share, and they're formal languages. How do you think about a painting? How do you make a deeper sculpture? The issue here was, how do you rethink those ideas in relationship to people who don't necessarily always think about materials and processes in the same way? **Architects use materials in a very different way. It's much further from the body.** I think the issue for this class was, how do you take that discursive difference and set it in motion so amazing things begin to happen? But I wasn't very conscious of that, in all hon-esty. The way I teach is just to talk to people.

DA I very much like this idea that somehow there is a strong direction, but teaching should not pull people by the nose ring, because it forces students not to look and makes them lazy.

JP I was impressed at how stratified the conditions were to some degree. It was really interesting that you could say to somebody, "No, don't do this. Go that way." And they do! In a graduate art program you would obviously expect something similar, but there would be some friction.

MM I was surprised that there was not more friction.

JP Really?

MM Yes, sometimes you get studios where a student will challenge the studio pedagogy much more fundamentally.

DA Yes, true. There should've been more challenge. I think we had a group of students who were ready to be taken on a journey, which is actually really, really good.

JP It was a super interesting exercise in terms of looking at this other culture. From my experience I like teaching architects. They do more, and they develop things in ways that are a lot more useful in a way, and not just about issues of utility. It can be really difficult to get art students out of their stylistic. They're all narcissists, because narcissism is a really productive engine in that culture, you know, and actually architects aren't like that. It's a much more communal training platform.

DA Architects are desperately always trying to be masters of many trades before forming an opinion. And the education process is seen as that sponge moment where you are soaking in as much as possible before you can actually start to say what it is that you might think you might need to say. **The Princeton program prepares students to become expansive thinkers rather than just producers.** And I think that it's a very useful skill to be able to deal with many issues that are shifting.

Tying your work back to a larger art context, I realized that for me, without you there is no Ai Weiwei. He's able to

produce in China, so it's very different, but in a way seeing his work made me realize how profoundly important what you've been able to do and what you continue to do is in changing the world, and how much you've already changed the world.

JP Thank you. Does he know my work?

DA I would be very surprised if he didn't know your work. He's very well-read and he knows what's going on in the world, so I would find it very surprising. And if he didn't, then that would be an incredible coincidence really. East and West. Sort of an explosion of molecules happening in a soup of celestial clouds.

JP The gallery work that he does is much more traditional, but then the buildings look really interesting.

DA The buildings are radically interesting. The way in which he steps out of what buildings are and uses them as other things — that, for me, is what he's learned from you. From my perspective, to see that your practice is actually real is very profound and quite amazing!

JP It's like being a folk artist!

Jorge Pardo

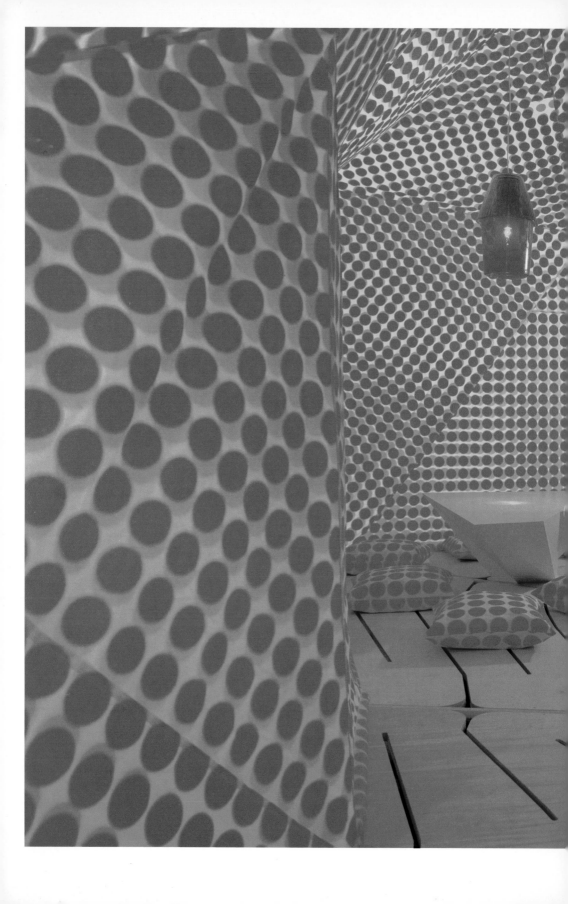

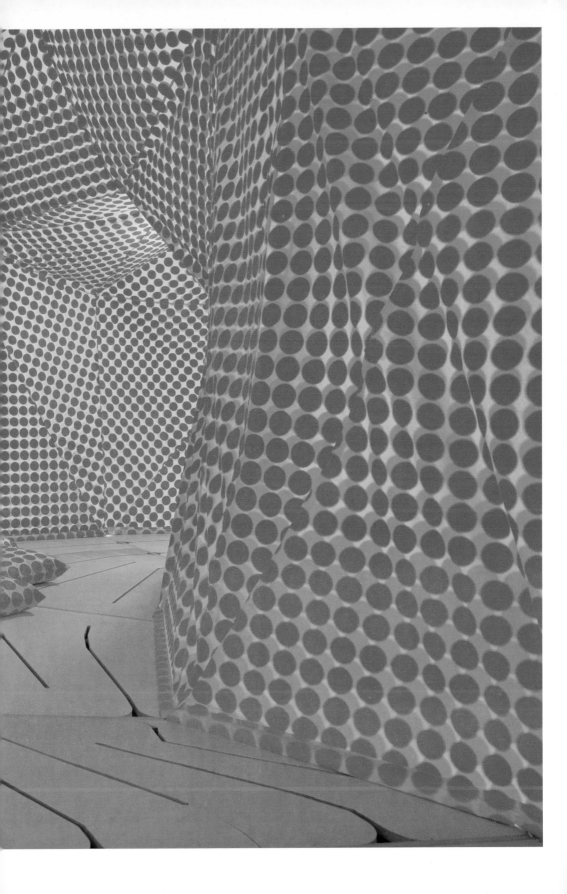

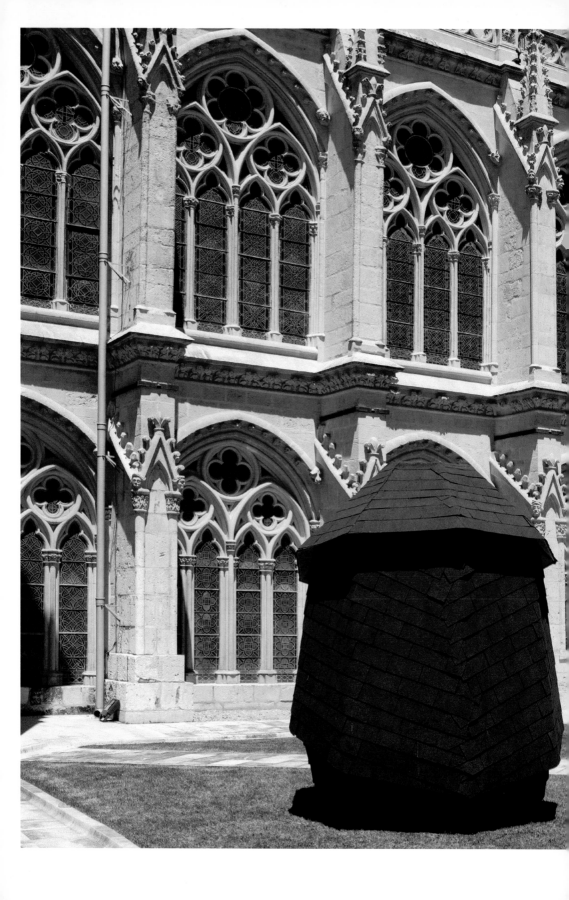

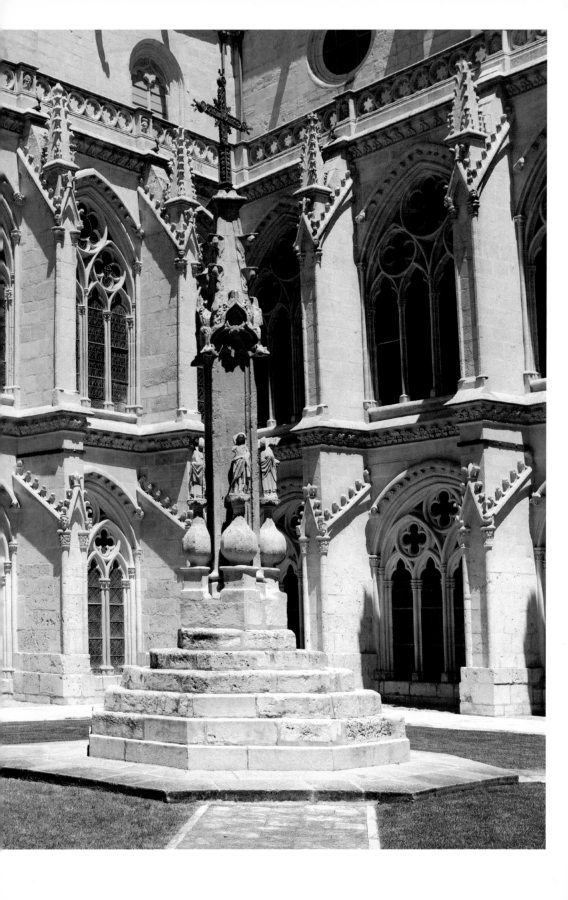

The Parallax View

Jorge Pardo and Alex Coles

[handwritten annotation: ← the transdisciplinary Studio Vol 1 (2012) Ed ~ Design and Art (2007) Jorge Pardo (2008)]

Alex Coles The interest your generation—Atelier van Lieshout, Tobias Rehberger and Andrea Zittel, et al—has in design and architecture is not so much in the disciplines per se, but in how the language developed in these fields enables you to establish a dialogical relationship with the viewer. Would you agree?

> **Jorge Pardo** So much has been said about my work's relationship to architecture and design but most of it is bullshit. It's not so much that my work contains references to architecture and design but how those references are made to work within an art context that is important.

AC Exactly. Spending time in your micro-studio in Mérida, the Yucatán, and your main studio in the Alhambra district of Los Angeles, has given me an insight into the way you run your practice. One thing that stands out compared with the other practitioners I've visited, where there are often discourse workers—critics and art historians—working alongside archivists in the studio, is your lack of care and caution when it comes to the critical discourse on your work. Given how this completely frames everything you do, isn't it crucial that you grapple with it?

> **JP** Up to now I've always resisted it, but recently I've been thinking that I actually need to introduce some sort of discursive platform within the studio to add a density to the discussions we have there. But at the same time, to produce both the work and the discourse with which to interpret it, means that you're fencing something in—that you're scared of what people may really say about it.

AC How would you introduce it? By having a discourse worker on the payroll?

> **JP** No, that's too creepy. I'll leave that to others. It would be more like having someone conduct occasional research in the studio, perhaps allowing students to pass through it—anything that really opens things up and prompts a richer dialogue between the studio members and myself and the work.

AC Let's focus on your new project which has been privately commissioned in the Yucatán—no one has heard anything about it yet. Due to be finished at some point next year, and with an as yet undefined program, the project consists of an interpretation of a ruined hacienda in Techoh, in the jungle about an hour from Mérida. The center piece is an enormous building with a grand staircase that takes you from the ground floor, which is at the foot of the jungle, and onto its roof, as if you are sitting on top of the jungle. From the roof you have a vantage point onto the six outer buildings and the numerous swimming pools that are dotted around the site. In both scale and ambition the project seems to be on a par with Rirkrit Tiravanija's *The Land, 1998—*, and Andrea Zittel's *High Desert Test Sites* project.

> **JP** In a way. It's all about controlling the frame, and each of us has a different way of doing that. But the essential difference between our projects is that Rirkrit and Andrea strive to establish a dynamic that includes presenting themselves as a part of the picture. As a result, their work, and those projects in particular, are highly emotive and at times even narcissistic. Channelling the point of entry and exit in this way is a deeply problematic gesture as it prescribes where the discourse on the work begins and ends. I think of what I do as my job—a job I very much like and one I get very well remunerated for. I clock in at nine in the morning and clock out at six in the evening. There is no big romance about it. If I need romance I have a relationship.

AC As you were making your way down to the Yucatán on this trip in your small airplane you stopped off at Donald Judd's ambitious project at Marfa, Texas. It seems like a very pertinent visit given your current project here.

JP Rather than modeling what I'm doing on Marfa, I was looking at Marfa and using it as a model to try and understand what I'm doing in Tecoh.

AC But Marfa is so problematic…

JP Absolutely. In part, it's a generational thing. To take the artwork out of the world and build high walls around it like Judd did is one of the deadliest moves you can make. One of the things I want to do at Tecoh is to think through the program—and that means interfacing with a public of some description. My work is nothing without a public and you need a program to bring them in. What that will be I don't know yet. Judd's relationship to this issue is very complicated. As everyone knows, Marfa came out of his frustrations with the way gallerists and curators controlled the frame and therefore the viewing conditions of his work, which he felt were seldom optimum. What I particularly like about Marfa is the way Judd kept his autobiography to a minimum. As a result, there are many points of entry and exit from it. If there is one thing I take from Marfa then it is that.

AC Can you say something about your studio model? Compared with someone like Judd, it is very different.

JP Judd is someone who had his work fabricated using postindustrial methods. At the same time, he felt the need to isolate himself in the overpowering natural landscape of the desert. The landscape of Marfa became a kind of object in his studio. This happens with me in the Yucatán. The difference is that I'm interested in how my work has some sort of relationship to the place that can be thoroughly embedded

183

in the studio and its output. Judd's sense of place and location was much more puritanical than mine. He left New York and established himself in Marfa because he found the city and the art world too stifling. The Yucatán is not a place of escape for me, but more a place where I can get things done—things that couldn't happen in L.A. Once those things are up and running then an audience is crucial.

AC Where Judd farmed out almost all of his production to specialist fabricators and eventually turned his studio into a design office and archive, you strive to ensure that the production process remains within your studio in order to understand precisely how it operates. This allows you to manipulate it further.

JP Precisely, it is crucial to my work that all of these skills and processes are embedded in the studio model. Without them, the work would be very different. After a while, it would become static.

AC What surprised me about visiting the studio in L.A. is how you often make major alterations to the work once it has been fabricated—even sometimes at the very last moment just as it is about to be shipped out—and insist on bringing it back to the design process.

The changes I witnessed all centered on the three palapas structures used in your exhibition at K21 in Düsseldorf in 2009. This is in sharp contrast with the often tightly planned process designers and architects work through during the design process—first refining a design, then a prototype, and only then moving on to fabrication. Using the studio as you do offers a greater degree of flexibility, and the ingenuity this introduces into the studio model expands your vocabulary and working methods. So why do you think Judd chose not to situate the process of fabrication—his primary means of production—in his studio when he stopped making them by hand?

JP Probably both the machines and expertise weren't so widely available to the degree they are now and at the price they are now. At the time it would have appeared like a more radical gesture to turn your studio into an office and so completely displace the traditional model of production by situating it physically somewhere else. That may be part of it. Because Judd made the gesture back then there seems little point in repeating it now.

AC John Baldessari is often held up as being a crucial player in the generation that developed the next crucial studio model in the 1960s, that of the "post-studio" artist. Since you have lived and worked in the same city as Baldessari for decades you must have a take on this.

JP Baldessari is representative of a particular period and that period still plays quite large today. Basically, the guys in his generation were hippies and they really believed that by changing the representation of their studio model they would change art. Their naivety has led to the total recuperation of their original project. Where previously I felt that the notion of the post-studio practitioner was bullshit, now I think this concept is actually the only thing interesting about the work. At its core is an attempt to resolve the moral issue of not making something yourself. If you look at post-studio art from that generation, it is always about legitimizing being an artist who doesn't actually make things with their hands. If you are in a culture and place where you are actually surrounded by manual work, that is much less of an issue and there is no need for such theoretical gymnastics to legitimize your feelings about it. At root, this version of the post-studio artist, with all of its hang-ups, is very southern Californian.

AC While being aware of the various ways the issue of the studio plays out in art, did architecture and design studio models —whose skills and technologies you draw from—also have a bearing on this?

JP No. As my work began to develop it was obvious that I needed to introduce an infrastructure—including new technologies and skills—that would complement it and then eventually push it further. So I started to collect people together who could work in the studio on the understanding that I would direct their particular skills and biases. This happened very gradually and in many ways I wasn't super-conscious of it.

AC You must have been for a start, you have someone who has a background programming at NASA.

JP In the beginning there was a guy who worked in the studio who was technically brilliant. With his guidance I bought my first machine. I wasn't so much interested in it as a thing but in what it could do—how it could push the studio's capabilities further. Then I hired people who could operate it at a more sophisticated level and interpret what I wanted. Eventually this led to John, who has the NASA background, coming on board. As I say, it was a gradual process.

AC In little more than a decade you have built a series of houses 4166 Sea View Lane in L.A., in 1998, The Reyes House in Puerto Rico, 2004–08, your private house in Mérida, 2003–08, and the living quarters at the hacienda in Tecoh. What strikes me when I see your buildings—and I think they are by far the most complex and dynamic aspect of your practice—is how they operate like self-reflexive sculptures first and as buildings second.

JP In many ways I'm a very traditional practitioner. From the beginning I chose to think of myself as a sculptor— and not even a modem one. Really what I run is an old school style atelier.

AC What is the relationship between the micro-studio you have in Mérida and your main studio in L.A.? After repeated visits to both, it seems like they are in parallax with one another.

parallel \ change: of objects due change in position

JP I'd actually like to use the work I'm doing here to enable me to become a part of the fabric of the culture; both fiscally and socially, by opening a real business, a bar like I did in L.A. —The Mountain, a bar above which I actually had one of my first studios—and later maybe even a restaurant. Basically, I love it down here. If Cuba had been available to me then I might have gone back there, but instead it's the Yucatán.

AC Why the need to branch out in the first place? Was L.A. becoming too limiting?

JP No, but having an axis like this can be dynamic. Things produced in the studio in Mexico can serve as a portal through which to view the studio production in L.A. Initially I came to the Yucatán over a decade ago and then just kept returning. At that point my principal interest in being here was to figure out why I wanted to be in a place like this so much. Then I began to import the things I usually did when I wasn't here—my work—so that I could be here more. It's as simple as that. Now L.A. has become the place where I produce things for exhibitions like the recent ones at Friedrich Petzel in New York and Gagosian Gallery in Beverly Hills, whereas Mérida is somewhere I produce much larger, more comprehensive things, such as the detailed interiors and furniture for the hacienda.

AC I've noticed that your vocabulary has expanded since you have been spending more time in the Yucatán—as if subtly registering the rhythms of the culture here. I'm thinking of the large paintings exhibited at K21 in 2009 and also recently at Gagosian Gallery, Beverly Hills. There has always been a 1950s–60s Verner Panton-type aesthetic underpinning your work, but now it has become even more formally elaborate, florid even. Again,

187

this must be connected to the way the micro-studio is embedded in the culture of fabrication and production of the area.

 JP When you interact with a place in this way it has to have some effect. To not register that the work was made here instead of in L.A. would seem like an odd thing to do. At the same time, I would never want it to become the single and explicit subject of the work. That would close it down to too great a degree.

AC First you produced things to go in rooms—such as your early lamps at Thomas Solomon's Garage in 1993—then the spaces in between these things—the four bedroom suites at Patrick Painter in 1998—followed by the buildings that contained them—Pier at Münster in 1997—and now the space between these buildings and, eventually perhaps, an entire mobile community in the Yucatán. With the development of your practice over the past two decades there has been a constant increase in scale. Many of the things you produce are associated with a wealthy lifestyle—a sailing boat for Chicago Museum of Contemporary Art in 1997, a glass house for MoCA, Los Angeles in 1998, a speedboat for Haunch of Venison, Zurich in 2005, designer furniture from your earliest exhibition at Neugerriemschneider in 1994, and further houses like The Reyes House. Have you ever interpreted your development in this way—especially now you have much more space and resources in the Yucatán?

 JP Remember that I grew up in a very working-class environment like you and so was always fixated on accessing material things associated with classes above mine. I like rich people's things—I just don't like the forms of etiquette and the general weirdness that so often accompany them. Look, in terms of the Yucatán, my presence here is very simple. I'm here for the same reason Coca-Cola are—to bring the unit cost of production down. The difference is that I actually like it here.

Adjaye Associates

MCA Denver

Shada

Wakefield

MCA Denver

Denver / U.S.A. / 2009

Adjaye Associates' first public commission in the United States advances the discourse on what a museum could and should be. It provides exhibition, education, and lecture spaces that address the needs of different art practices, and their design encourages a sense of intimacy with the art and the artists. Strategically placed picture windows and a roof terrace overlooking the city create continuous connections with the urban context, emphasizing the relationship between the city and the museum. Internally the museum is intended to be a microcosm of the city: rather than moving from one exhibition space to another, visitors always emerge onto a street-like space before moving to another gallery.

In keeping with the scale of the neighboring buildings, the main volume of the new building has a height of four generous storeys. In order to establish a visual relationship with the traffic moving into and out of the downtown area, the northeast façade is set at a slight angle to 15th Street. The southeastern corner of the building has been pulled forward so that, in the form of a projecting vertical strip, it is visible from the metro station on Delgany. This corner is the location of the main entrance onto the site and into the museum. The art spaces are arranged in three separate stacks standing within a larger enclosure. The space between the stacks and the enclosure is used primarily for circulation, while the space between the stacks themselves is used to bring natural light into the heart of the building. Two of the stacks support the members' room and the education spaces, and the third one supports an enclosed roof terrace.

On completion, MCA Denver achieved the distinction of Gold Leadership in Energy and Environment Design (LEED). Pioneering sustainability and assuming a leadership role in the reduction of energy consumption, greenhouse gas emissions, and use of raw materials, it was the nation's first LEED certified contemporary art museum.

Materials
Grey glass / Monopan / Concrete / Tinted concrete / Grey stained redwood

Total area: 2,320 m^2

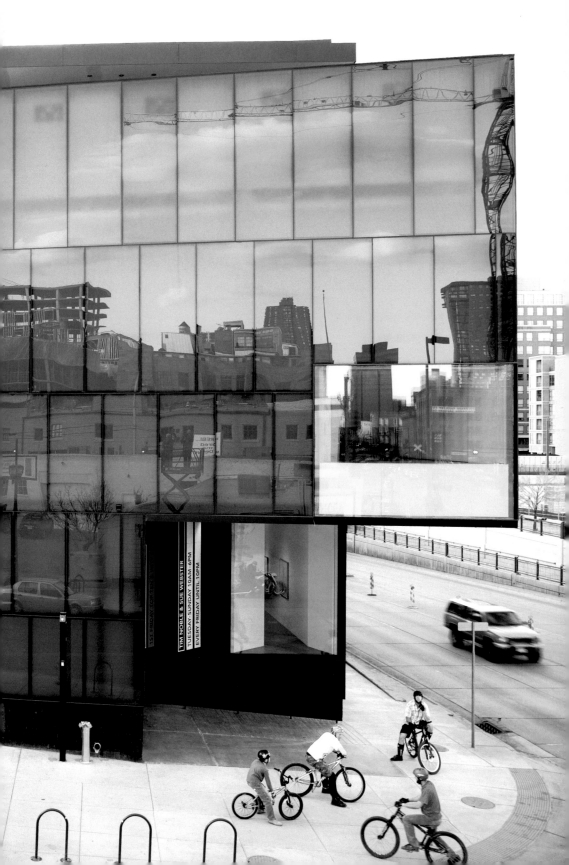

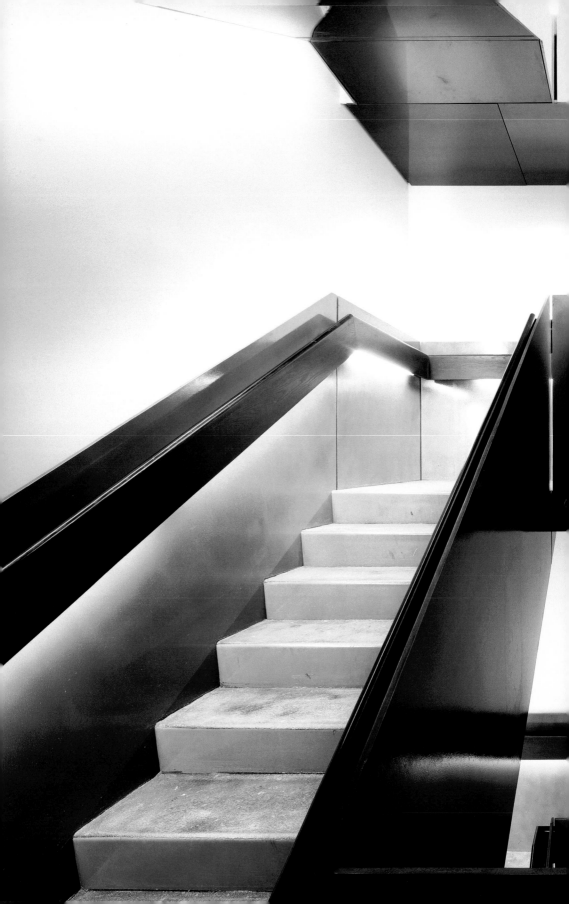

Shada

London / U.K. / 2009

This project was based on a collaboration with the artist Henna Nadeem, who is concerned with the importance of pattern in visual experience. The original commission was for a work of art to stand in a green square at the heart of a rebuilt housing estate in London's East End. In contrast, the structure that was eventually built is intended to encourage social interaction by providing a sheltered space where local residents can meet and parents can sit and read with their children. Despite this change in emphasis, an artistic dimension is still apparent in the interaction between the various elements of the pavilion and their relationship to the landscape.

In response to the landscape setting, the memory of London Plane trees is evoked by the laser-cut apertures in the corten steel roof, which are based on Nadeem's studies of the shadow pattern created by the leaves of the trees. The roof is supported by irregularly spaced columns, like the trunks of trees in a forest, with small stainless steel tables and benches below. Occupying a central position in the square, the pavilion emphasises the importance of this space to the local community, and its circular form addresses the surrounding houses on an equal basis.

Materials
Corten steel / Galvanized steel / Stainless steel

Total area 58 m^2

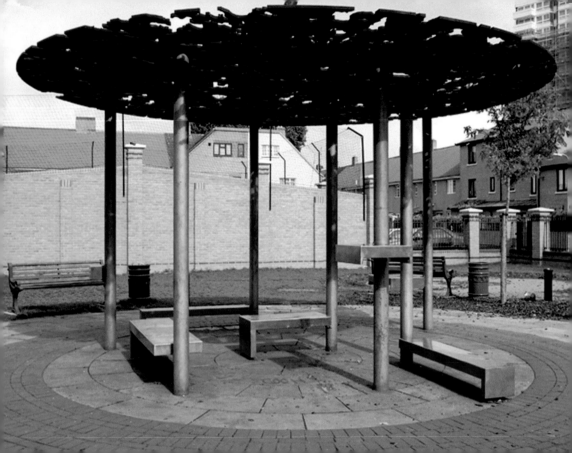

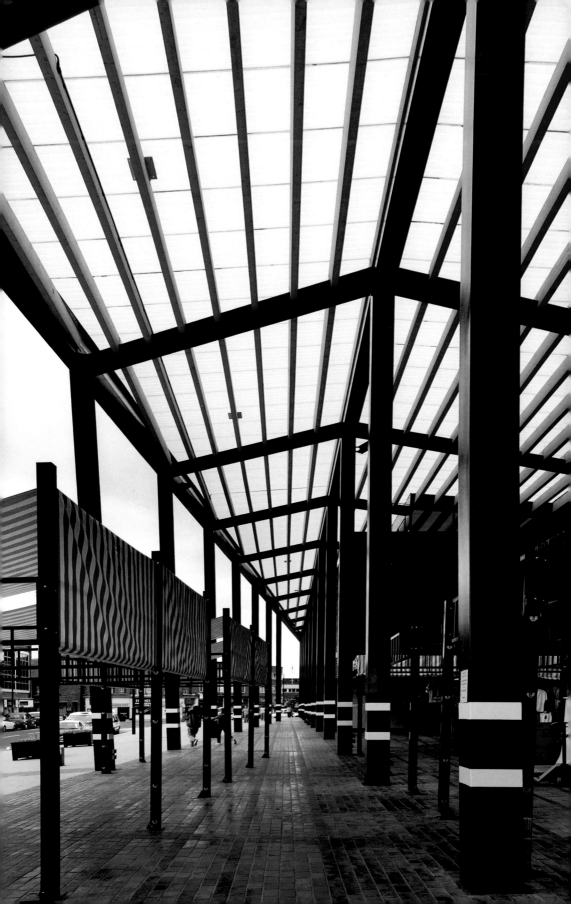

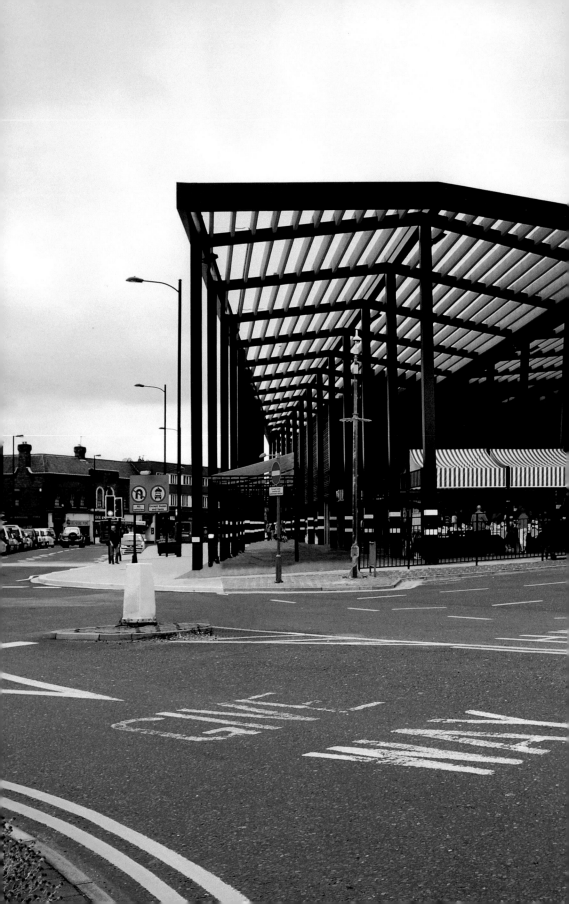

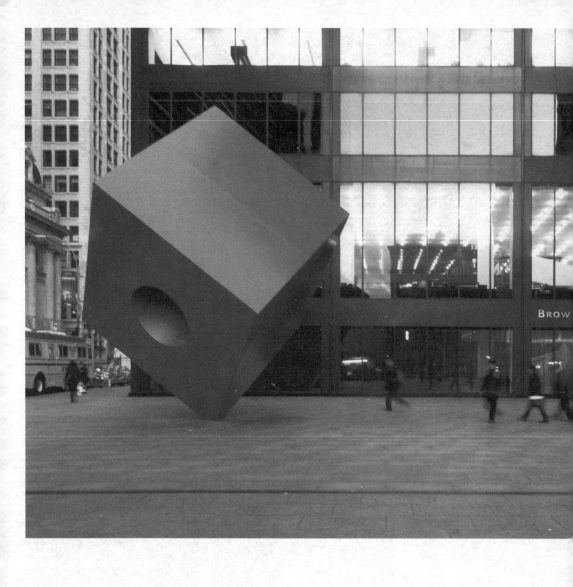

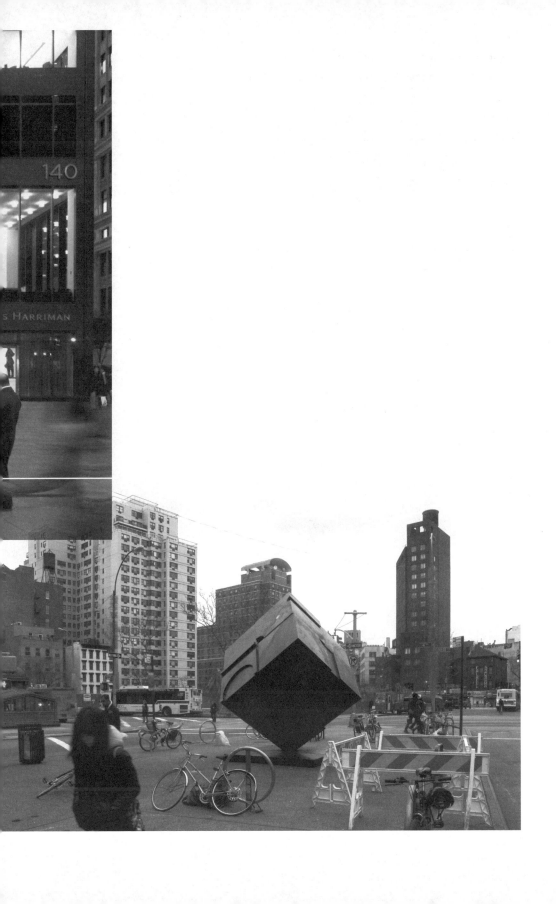

205

Eclipse / Charles Perry / 1973

Yucatán Mirror Displacement (2) / Robert Smithson / 1969

206–207

United Nations Building / New York City / 1953

Bronze Screen / Harry Bertoia / 1954

Bauhaus / Dessau / 1930

208–209

Red Cube / Isamu Noguchi / 1968

Alamo / Tony Rosenthal / 1967

New Jersey / Matthew Ritchie / 2008

David Adjaye and Anthony Fontenot

Students: Michael Alexander, Zach Cooley, Sarah Jazmine Fugate, Brian Ha, Chris Hillyard, Thomas Kelley, Nicole Liao, Edward Yung

Gowanus / Teresita Fernández / 2009

David Adjaye and Marc McQuade

Students: Robert Cha, Craig Cook, Laura Diamond, Miku Dixit, Yuanrong Ma, Matt McMahon, Chrissy McMillan, Bryony Roberts, Philip Tidwell, Chris Yorke

Yucatán / Jorge Pardo / 2010

David Adjaye and Marc McQuade

Students: Matthew Clarke, Brandon Clifford, Kai Franz, Razvan Ghilic-Micu, Barbara Hillier, Viviane Huelsmeier, Ang Li, Samuel Stewart-Halevy, Matthew Storrie

New Jersey

The New Jersey periphery has long served as a shared frontier for art and architecture practices. In the 1960s and 70s, the outskirts of New York provided a vantage point from which to understand the city center. It was here—in the discovery of ruins in reverse, the empty turnpike, and Homes for America—that disciplinary boundaries began to erode, giving way to a space of productive overlap.

In framing the site for the studio, we returned to this shared space. Students were given free reign to choose a site within New Jersey; the political outline provided the only constraint. The continuous development of the state brought about a new line of questioning. As New Jersey quickly approaches an unprecedented moment of "total build-out"—the point when no more new land is available—this definition of fullness belies the utter scarcity of the exurban landscape. The state is the densest in the nation, and yet it has no major city. How might an architect work within this ambiguous territory? Where can we stake our ground?

The openness of the brief provoked a range of scales and strategies within the student projects. Suburban parking lots, abandoned factories, commercial villages, swamps, and beaches were taken up as sites of speculation. Through the invention of new narratives—utopian, anthropological, scientific—one could project a scenario of recovery, and perhaps quell the anxiety of the landscape.[1]

Notes
1. Antoine Picon, "Anxious Landscapes: From the Ruin to Rust."

217

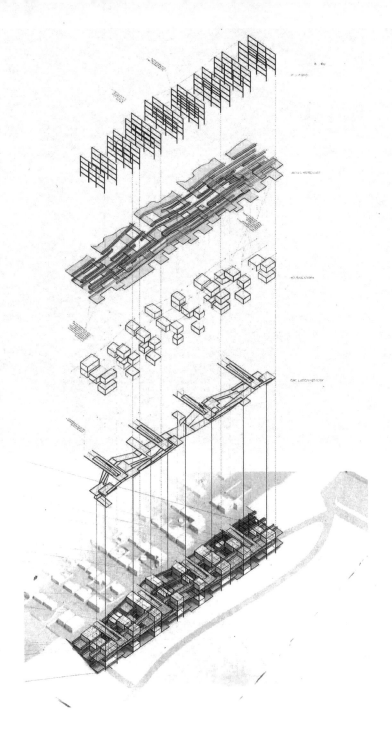

Michael Alexander

219

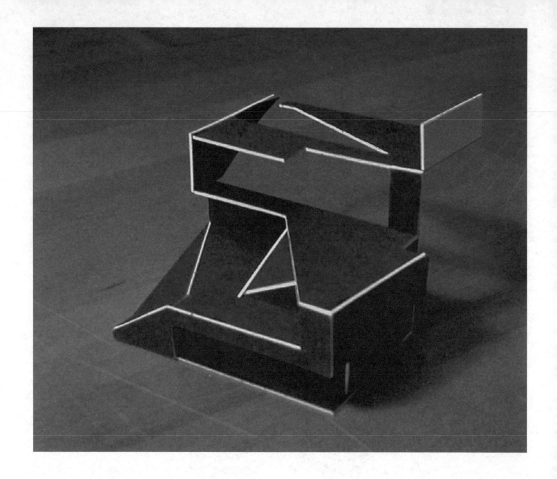

Zach Cooley

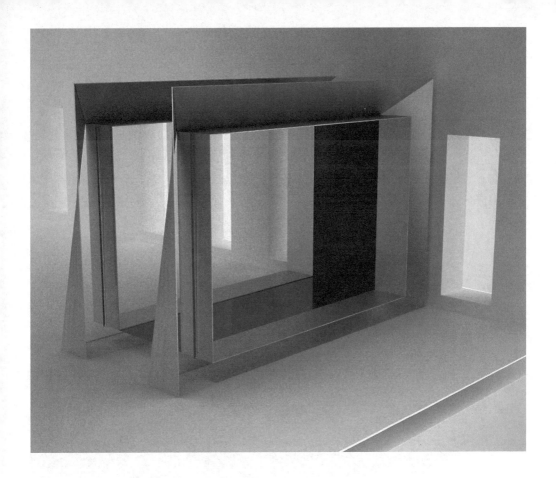

Sarah Jazmine-Fugate

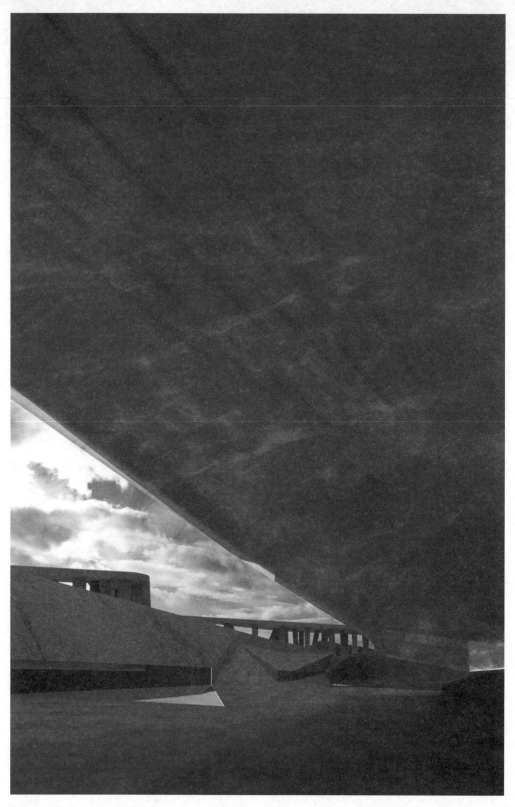

Brian Ha

Distend
Chris Hillyard

How does one operate from within? Taking the generic parking lot and landscape of the big-box "retail power center" as a site of projection, this project examines a banal and accepted spatial condition which is central to the experience of New Jersey.

Through the incremental appropriation of the parking lot in space and over time, a new form of order begins to swell up from the ground. This structure is discovered internally, and feeds off the commercial metabolism of the "retail power center," bloating the brackets of the car park. The project harvests the potential of the residual spaces, times, and uses of the parking lot by subtly inflecting the standard components that comprise the car park. Gradually, new patterns of use proliferate and gain an independent form.

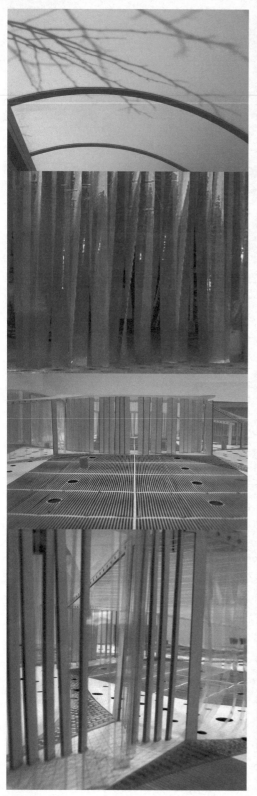

Chris Hillyard

224

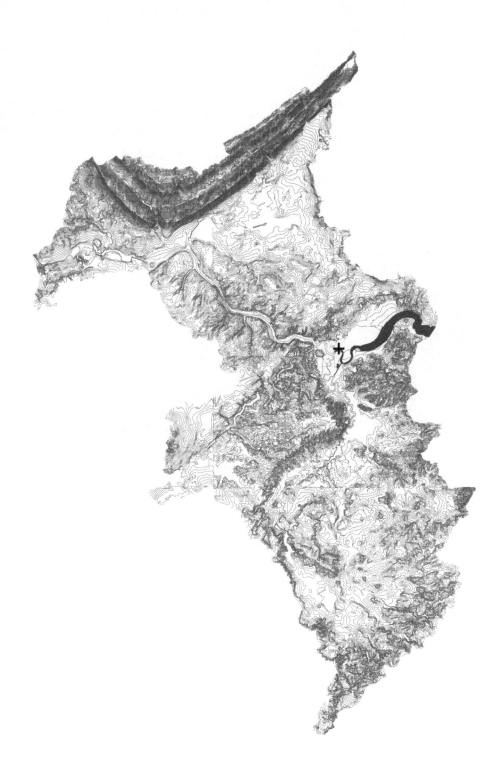

Thomas Kelley

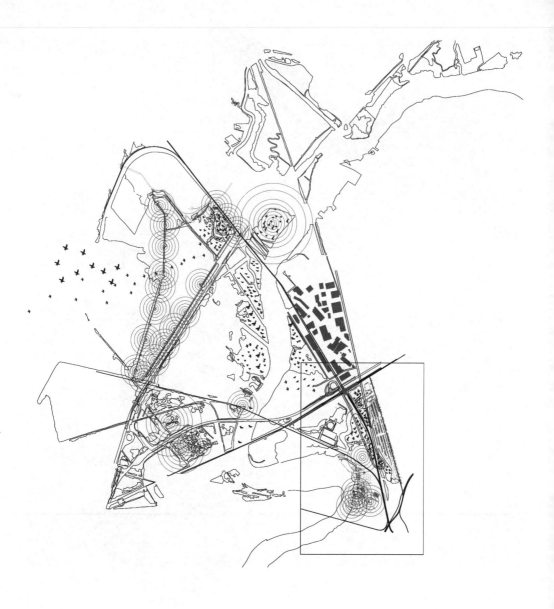

Nicole Liao

226

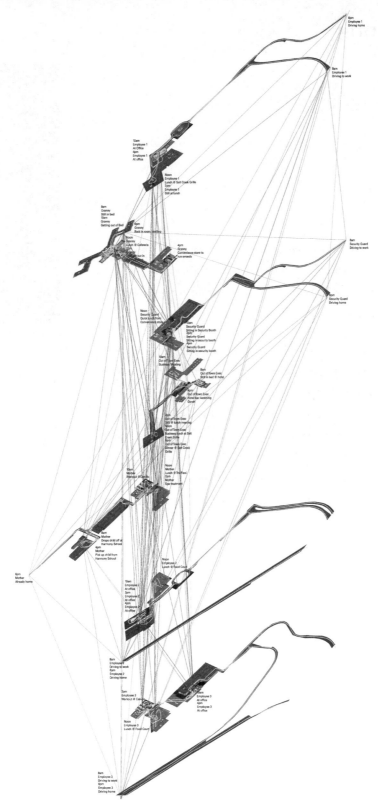

8am
Employee 1
Driving to work

4pm
Employee 1
Driving home

10am
Employee 1
At Office
4pm
Employee 1
At office

Noon
Employee 1
Lunch @ Salt Creek Grille
2pm
Employee 1
Still at lunch

8am
Granny
Still in bed
10am
Granny
Getting out of Bed

4pm
Granny
Back in room, meeting

Noon
Granny
Lunch @ Cafeteria

out in

4pm
Granny
Convenience store to
run errands

8am
Security Guard
Driving to work

4pm
Security Guard
Driving home

Noon
Security Guard
Quick lunch from
Convenience store

10am
Security Guard
Sitting in Security Booth
2pm
Security Guard
Sitting in security booth
4pm
Security Guard
Sitting in security booth

10am
Out of Town Exec
Business Meeting

8am
Out of Town Exec
Still in bed @ hotel

4pm
Out of Town Exec
Forced fun; watching
Oprah

8pm
Out of Town Exec
Still @ lunch meeting
Noon
Out of Town Exec
Business lunch at Salt
Creek Grille
8pm
Out of Town Exec
Dinner @ Salt Creek
Grille

Noon
Mother
Lunch @ Tre Plain
2pm
Mother
Spa treatment

10am
Mother
Workout @ Gym

8am
Mother
Drops child off at
Harmony School
4pm
Mother
Pick up child from
Harmony School

4pm
Mother
Already home

Noon
Employee 2
Lunch @ Food Court

10am
Employee 2
At office
2pm
Employee 2
At office
4pm
Employee 2
At office

8am
Employee 2
Driving to work
6pm
Employee 2
Driving home

2pm
Employee 3
Workout @ Gym

10am
Employee 3
At office
4pm
Employee 3
At office

Noon
Employee 3
Lunch @ Food Court

8am
Employee 3
Driving to work
6pm
Employee 3
Driving home

Edward Yung

227

Gowanus

How close can one get to a figure, an object, or a landscape without ever touching it? Is it possible to render the toxic exotic? In choosing the Gowanus Canal as an architectural site, we were aware that we had set up a problem with ludic dimensions: In order to canoe in a sewer, one must have both a paddle and a sense of humor.

The Gowanus canal has never been pristine. In its former life as a tidal inlet, the basin received much of the runoff water from the surrounding areas of South Brooklyn. Construction began on the canal in the mid-19th century in order to accommodate growing demand from New York's maritime industry. Following its completion in 1860, coal yards, gas works, cement makers, tanneries, and paint and ink factories moved into the newly created dock areas. By 1911, the canal had become so polluted that the city had to construct a 12-foot tunnel in order to flush contaminated water into the New York harbor. In the 1960s, many of the factories were abandoned, leading to further decline in the surrounding working-class neighborhoods of Carroll Gardens, Cobble Hill, Red Hook, and Park Slope. In more recent years, as development has moved south, the Gowanus has begun to witness a resurgence. Areas along the canal have been repurposed for arts and culture, new housing, galleries, and even a canoe club.

From the outset of the studio, the Gowanus was contextualized as a non-standard site that therefore required non-standard modes of questioning, developing, and testing. The figure of the canal—the constancy of its width, its dead ends, its hard edge—became a major preoccupation. Through the introduction of artificial atmospheres, ramps, secondary infrastructures, and esoteric programs, the division between land and water could be reconsidered.

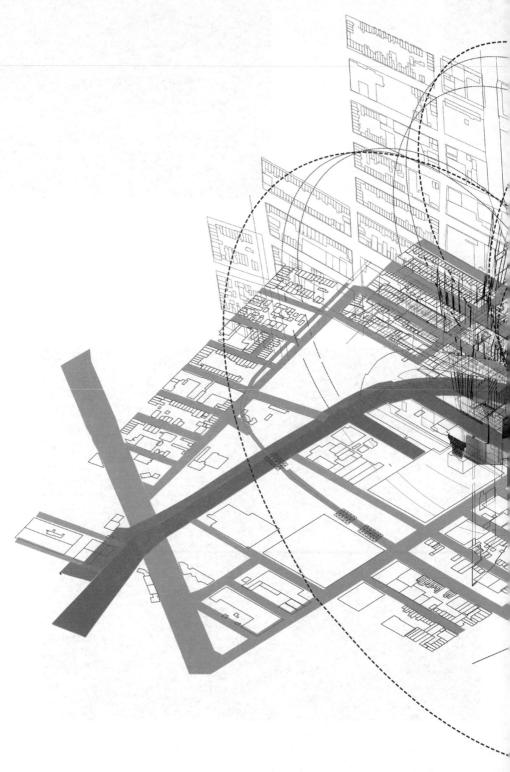

Robert Cha

234

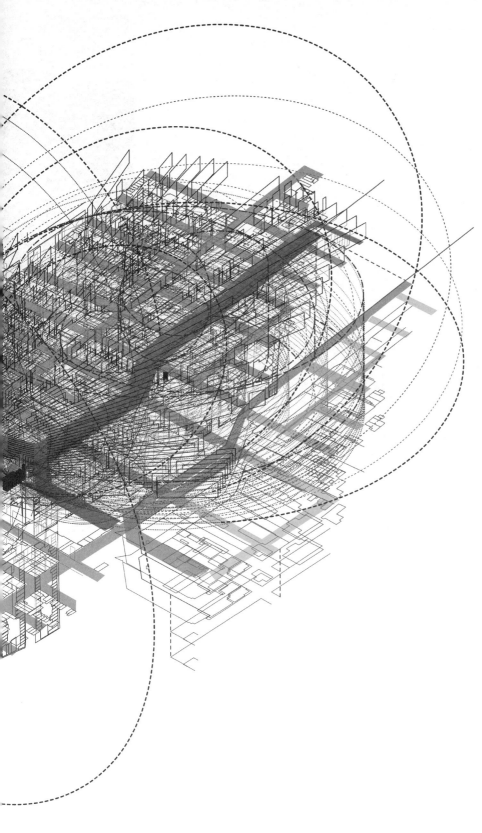

Parallel
Craig Cook

The Gowanus canal's geographic situation makes it a sewer of last resort for the neighborhoods that surround it. "Natural" remediation strategies that revert the canal to a pre-industrial state will not change this. Supergowanus is a proposal to embrace the canal's status as a sewer, "double-bagging" it with an outer shell that directs sewer outflow to a sub-canal beneath the canal. In this new infrastructure there are insertions that create pathways and occupiable spaces that reveal the doubling infrastructure, creating heightened awareness and communication with the canal itself.

Using the whole canal as a site required a linear mode of development in models and drawings. These resolved as strings, threads, paths, and slices. As the project was predominantly subterranean I had in mind the striations of a soil core sample, or the kind of cut-away view of tectonic plates found in a geology textbook. These two influences merged in model making, the "soil core" became the "threads" that would run the length of the linear site as thin chipboard flipped ninety-degrees on its end in the layered manner more typically used to show elevation in a site model. Voids and openings were cut into the deep "threads" of chip board. The final model became a kind of MRI scan slicing through the body of the Gowanus itself.

236

237

Laura Diamond

238

240

Disperse
Miku Dixit

When do we know we have arrived at a particular site? Mist from steam
tunnels surrounding the Gowanus Canal finds itself constrained to a horizon-
tal datum, tracing a contour across the subtle shifts in grade in the area
surrounding the canal. An elusive threshold condition otherwise only legible
in plan is made visible, immersive and corporeal. The intervention first takes
on a figural character as a contour against surrounding topography. Next,
it becomes a datum as the ambulatory gaze crosses a horizontal threshold
turned vertical. Finally, the intervention turns to the third state of pure atmo-
sphere as the subject is completely immersed in a mist dispersed from the
steam tunnels running along the streets below.

The installation that was created for the final review had to express quali-
ties of this project through novel techniques of representation. Not a single
drop of water was used. Instead, atmospheric conditions of mist and fog were
simulated through digital projections onto several taut layers of transparent
nylon placed two inches apart. Orthographic projections of the project shift-
ing from plan, to street sections to elevations were animated and projected
to scale onto the layers of nylon from two directions allowing simple white on
black drawings to take on depth and motion.

Yuanrong Ma

243

Authentication

Matthew McMahon

In order to imagine a scenario of recovery for the Gowanus canal, I jettisoned traditional architectural strategies in favor of archaeological and forensic methods. The Gowanus soil formed a body of historical evidence—a composite of glacial sediments, salt marsh peat, urban grit, industrial chemicals, bullets, blood, and remains from the Battle of Brooklyn. My method of representation was to work, somewhat literally with this substance—to bring the soil into the studio and to appropriate it as a medium for drawing.

After some initial experiments with ink and plasticine, I developed a representational technique using rigid plexiglass. I would make deep etches into the glass plates, forming troughs and basins within which the collected soil could settle. This provided clarity to the line work, but still allowed for the fiber, grit, water, and humus of the soil to register. Each plate could be read as a two dimensional plan, drawn and built with the site's soil. When collected, stacked, illuminated, and perceived together, the drawings took on a three-dimensional quality—resembling the striations of the earth.

244

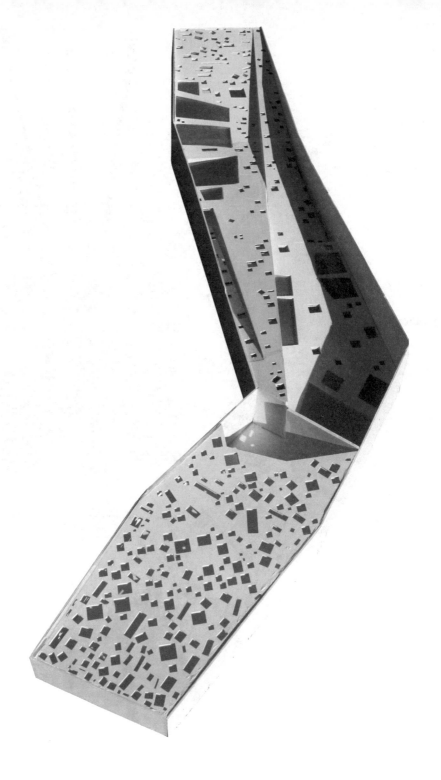

Chrissy McMillan

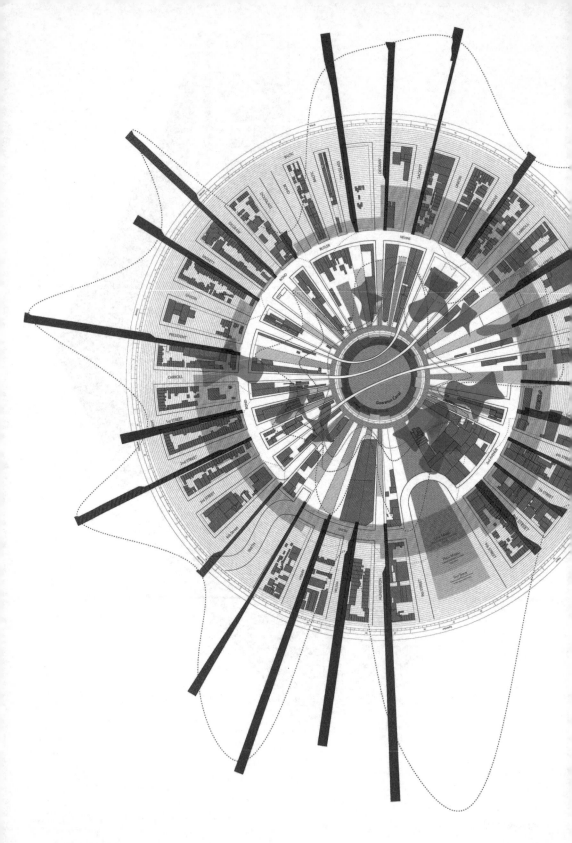

Cartography
Philip Tidwell

Mapping is generally deployed as a means of demonstrating a particular set of relationships. From the well known insurance maps that delineate property ownership and street organization to the touristic caricatures and subway maps that take liberties with the Cartesian order to more clearly demonstrate adjacency and organization.

In the case of Gowanus, the map is deployed as a tool by trading the orthogonal grid of streets for a polar grid (with the canal basin at its center). The canal appears less familiar, less fixed and perhaps subject to broader reconsideration. Public streets that terminate in the canal are folded into its basin, increasing stormwater capacity and thus reducing sewage overflow during heavy rains. Each street section is mapped in relation to the total design scheme, and its relationship to the larger area can be immediately understood in the context of the entire urban scheme.

Bryony Roberts

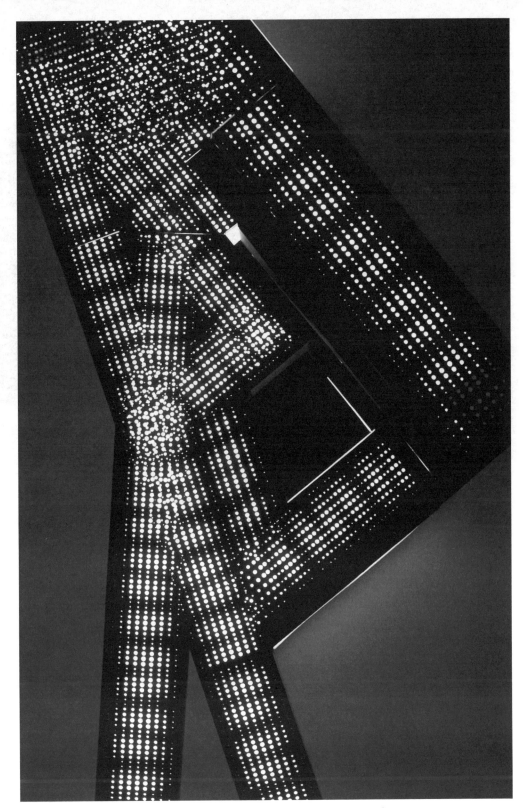

Chris Yorke

Yucatán

The Mérida studio played out against the backdrop of the jungle. And perhaps there was no more fitting context for our discussions on the collapse of art into architecture (and vice versa) than the compressed topography of the Yucatán: A thin layer of brush sandwiched between porous bedrock and the open sky. Once in Mexico, we gladly exchanged the dialectics of inside and outside—the definition of disciplinary territories—for questions of surface and depth. Climbing above the canopy afforded an uninterrupted horizon. To descend into one of the caverns was to commune with the gods. Here, in the lower reaches of the *cenotes*, one could find altars, lakes, and the skull of a two thousand year-old bear.

Over several days, the Yucatán was revealed in all of its stratifications. The contemporary developments of hacienda tourism and *fraccionamiento* housing were occurring alongside a rural population that seemed divorced from history. During nighttime drives, the jungle was interrupted every so often by candlelit interiors—through open doors, women could be seen practicing the *Ballet Folklórico*.

Though the studio was nominally associated with the city of Mérida, the students' work was as much about coupling a sense of place with a sense of time. Processes—basic gestures of pottery and weaving, the imagined transposition of monuments, the recycling of stone, the synchronic mapping of sounds and locations—became sites in and of themselves. In adopting these time-based methods, we attempted to "produce production"—to remove ourselves from the immediacy of projection in order to question the very nature of authorship in architecture.

Kai Franz

Fiction

Ang Li

A predominant catalyst for the Mérida studio appeared to be the lack of an established context. The removal of the word "constraint" from the dreaded notion of site constraints upgraded the site from background to foreground, whereby an anchored sense of place was replaced by an agglomeration of found materials to be cut up and reconstituted. The collage recommended itself as the ideal medium for a kind of site analysis through reconstruction. Photoshop, in turn, became the obvious instrument for the speedy adulteration of stale facts with imported fictions.

The project combines found images of Mérida's civic and religious icons, with photographs, and video footages of the unsung monuments of Newark, N.J. The absence of context suggested a level of universality, through which "nowhere" became synonymous with "anywhere." What was once geographically specific was rendered ubiquitous, resulting in the creation of a series of site-less counterfeit landmarks. The function of the collage in this instance was a way of establishing a frame of reference, through which overly reproduced images of the city could be redeemed by a change of scene. Ultimately, the collage transcended its role as a mere form of representation of built reality, and became instead the means of authentication for its doppelganger.

258

Brandon Clifford

Matthew Clarke

260

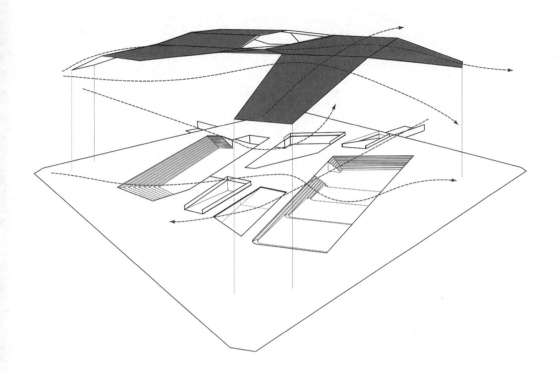

Razvan Ghilic-Micu

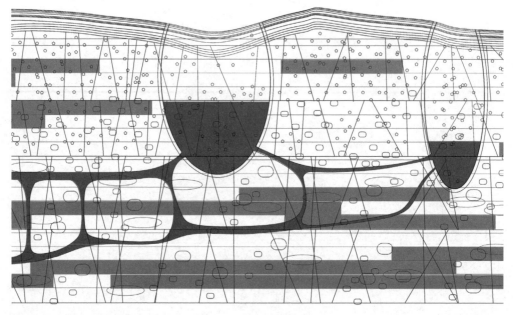

Barbara Hilier

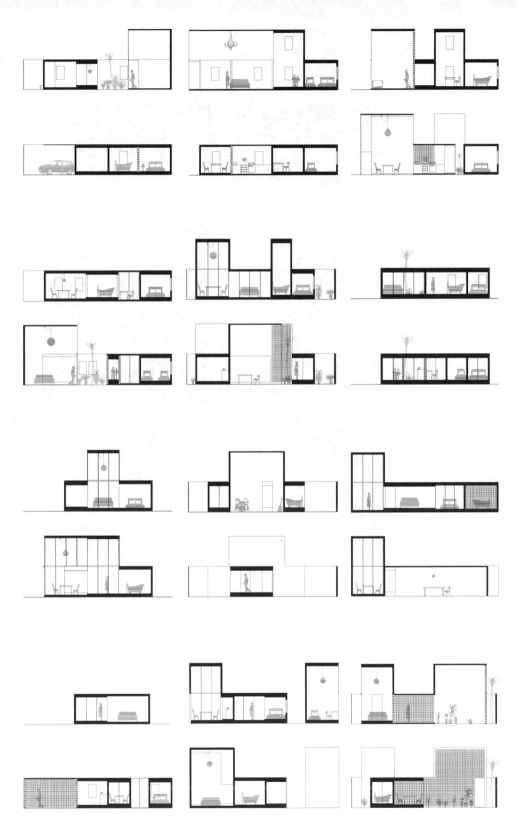

Viviane Huelsmeier

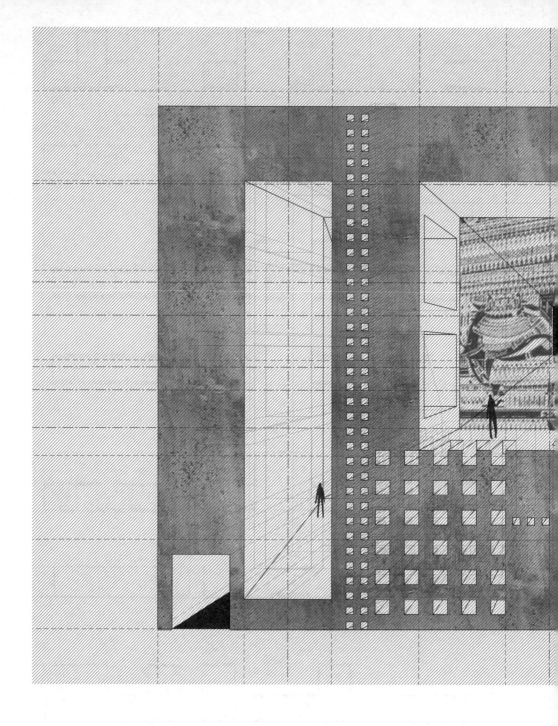

Ang Li

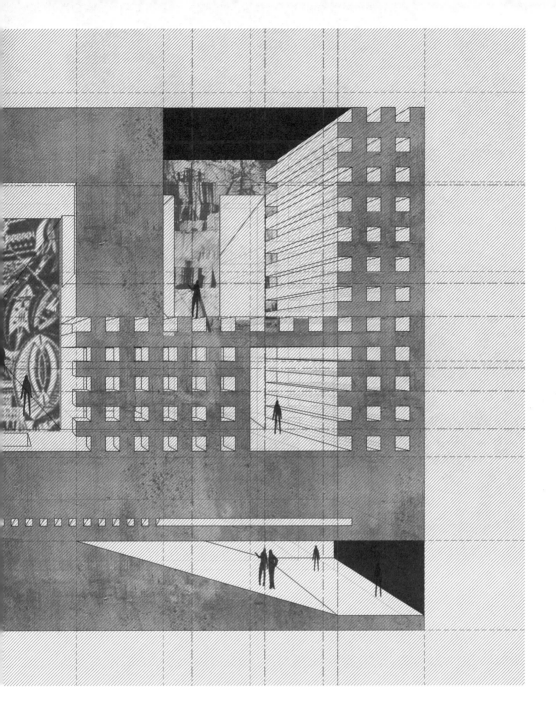

Loop
Samuel Stewart-Halevy

When an architecture studio is guest taught by an artist, the question of interdisciplinarity is automatically brought to the fore. Although we were given a literal site in Mérida, I also thought of the art practice of Jorge Pardo as a type of site. What I found very interesting in his work was the idea that one could operate within more than one discipline without becoming an expert, and in that way, one could make meaningful work that was really separate from discovering the truth of those disciplines.

In my proposal for Mérida, I employed the conventions of travel writing, anthropology, historical research, and ceramics without acting within those disciplines. Throughout the term, I casually exchanged objects and information between these realms of production and knowledge. My method could be diagrammed as a sort of loop or figure eight, always circling back to Mérida. For the final model, misshapen pots, thrown upon a wheel, have been transposed onto a site and assigned a scale and function. Ultimately, finding a certain kind of amateurism through the wrong way of doing things was more informative than the employing of a scientific method.

Chronometry
Matthew Storrie

Although the city of Mérida typifies contemporary urban models—historical center, industrial ring, growing suburban periphery—the parameters of the project resisted a site strategy based on spatial and geographic relationships. Without a fixed site, temporality and the artifice of the architectural act could subordinate spatiality. It became more interesting to treat our visit to the Yucatán as an unfolding object of inquiry. The methods of engaging the city as outsiders provided greater potential than spatial exploration in defining its contemporary urban state.

With these re-formed parameters, the investigation became a rigorous and rhythmic exercise in observation during the seven-day trip. Using the ordinary architectural tools, I sketched my immediate surroundings once per hour (excepting sleep); unbeknownst to my colleagues, I also recorded audio tracks of each of these moments. This operation divorced the drawing set from candid observation, providing a tool for later observation and analysis. Capturing native and foreign interactions, the resulting audio clips collapsed architectural convention, city life, social interventions, and skepticism of the architectural act into one ambiguous layer. Drawing became a farce, a lampoon, a satire of the architect at work, mired in layers of urban interactions lost to the pen and paper.

268

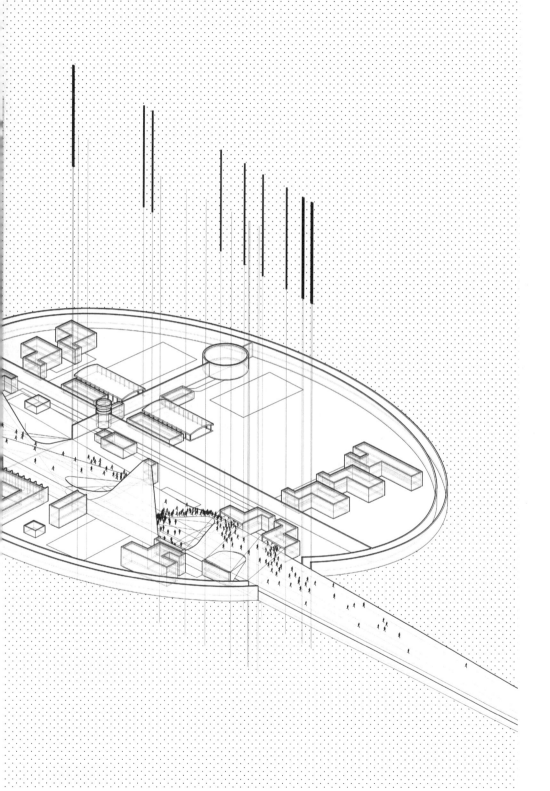

The generous support of Elise Jaffe + Jeffrey Brown benefited this project enormously from its inception. Their insatiable intellectual curiosity and deep commitment to architecture continue to enrich our discourse.

We are especially grateful to Matthew Ritchie, Teresita Fernández, and Jorge Pardo for their extraordinary creativity and willingness to collaborate. Behind these artists stand several people who facilitated the translation of their artwork to the printed page: For Matthew Ritchie, Andrea Cashman and Renee Reyes at the Andrea Rosen Gallery; for Teresita Fernández, Stephanie Smith and Gregory La Rico at Lehmann Maupin; and, for Jorge Pardo, Jody Asano at Jorge Pardo Sculpture. Ana Paula Ruiz Galindo and Mecky Reuss were our gracious and tireless hosts in Mérida. Many thanks to Claudia Madrazo and Roberto Hernandez for their generous hospitality and lively discussions.

Special thanks to Sanford Kwinter, Dave Hickey, and Alex Coles for their written contributions. Particular thanks to Margaret Miller at the USF Contemporary Art Museum for her help gaining permission to republish Dave Hickey's essay.

Our thanks to the many photographers whose images are featured throughout these pages, as well as those who permitted us to include archival photographs: Catherine Belloy at the Marian Goodman Gallery, Shelley Diamond at JPMorgan Chase, Stephen Henderson from the Nigel Henderson estate, Louise Oliver at Tate, Erica Stoller at Esto, Philip Tan at the James Cohan Gallery, and Jim Wintner at PhotoGraphic Gallery.

Thank you to the Princeton School of Architecture and the students who made our time there such an amazing experience. Particular thanks to Samuel Stewart-Halevy, who worked as a research and editorial assistant during the early stages of the book's development. The assistance of the Princeton School of Architecture staff proved essential, most especially Cynthia Nelson, Fran Corcione, Rena Rigos, and Camn Castens.

Zoë Slutzky rigorously copy edited the book and made valuable suggestions. Thank you to Peter Allison, Ama Amponsah, and Gayle Markovitz for their help with the Adjaye Associates work.

We're grateful for Lars Müller's thoughtful encouragement. Our thanks to Luke Bulman and Jessica Young of Thumb for their great work in realizing this book. Finally, we are indebted to Stan Allen, a generous dean as well as a perceptive, encouraging, and compelling voice of reason. His intellectual rigor and unwavering passion for teaching and architecture

David Adjaye OBE is founder and principal architect of Adjaye Associates, an international architectural practice responsible for work ranging in scale from private houses, research projects, exhibitions and temporary pavilions to major arts centers, civic buildings and masterplans across Europe, North America, the Middle East, Asia, and Africa.

Stan Allen is an architect working in New York City and the Dean of the Princeton School of Architecture. His most recent book is Landform Building: Architecture's New Terrain.

Alex Coles is Professor of Transdisciplinary Studies in the School of Art, Design and Architecture, University of Huddersfield. He is the author of The Transdisciplinary Studio and editor of Design and Art.

Teresita Fernández is a conceptual artist best known for experiential, large-scale work inspired by landscape and natural phenomena. She is a 2005 MacArthur Foundation Fellow and the recipient of numerous awards including a Guggenheim Fellowship, a Louis Comfort Tiffany Biennial Award, an American Academy in Rome Affiliated Fellowship, and a National Endowment for the Arts Grant. In 2011, President Obama appointed Fernández to the U.S. Commission of Fine Arts.

Dave Hickey writes fiction and cultural criticism. He lives in New Mexico.

Sanford Kwinter is Professor of Architectural Theory and Criticism at Harvard University and co-Director of Master in Design Studies Program. He writes frequently on science, philosophy and aesthetics.

Marc McQuade taught with David Adjaye during the Princeton studios. He is a project architect at Adjaye Associates and co-editor, with Stan Allen, of Landform Building: Architecture's New Terrain.

Jorge Pardo was born in Havana, Cuba and studied in Chicago and California; he lives and works in Los Angeles.

Matthew Ritchie is a New York based visual artist whose installations have extended the concept of painting to include film, wall drawings, architecture, performance, and sculpture in an ongoing exploration of how we visualize and understand cultural narratives and the information embedded in them.

Credits

Authoring
re-placing art and architecture

Edited by Marc McQuade

In cooperation with the Princeton School of Architecture

Design: Thumb, New York
Typeface: Akkurat
Copy editing: Zoë Slutzky
Printing and binding: Regal Printing, Hong Kong

A generous donation from Elise Jaffe + Jeffrey Brown has supported
the project from inception to publication.

Visiting artists for the Adjaye studios were partially funded by
the Lewis Center for the Arts at Princeton University.

Lars Müller Publishers
Zurich, Switzerland
www.lars-mueller-publishers.com

ISBN 978-3-03778-282-8
Printed in Hong Kong